CHILDREN
OF THE BLACK TRIANGLE

ACKNOWLEDGEMENTS

A big thank you to all the people who have contributed to *Children of the Black Triangle*.

QUOTES: *Marcus Garvey*
Marcus Garvey and the Vision of Africa
Edited John Hendrik Clarke with the assistance
of Amy Jacques Garvey
Vintage Books.

Walter Rodney
How Europe Underdeveloped Africa
Bogle – L'Ouverture Publications.

Haki R. Madhubuti
Earthquakes and Sunrise Missions
Third World Press Chicago 11

Black Chronology compiled by Etienne Dwumah

First published in Great Britain 1988 by
SEED PUBLICATIONS
P.O. Box 852
London W11 4RY, UK

© ARMET FRANCIS

First published in the United States 1989 by
AFRICA WORLD PRESS, INC.
P.O. Box 1892
Trenton, NJ 08607

Library of Congress Catalog Card Number: 88-83755
ISBN 0-86543-129-9 Cloth
ISBN 0-86543-130-2 Paper

Photo of Armet Francis
Paul Misso 1988
Fraser's Studio 1953

Designer – Christina Y. Hicks

Typesetting – Olga Graham

Printed in Great Britain by
Jolly & Barber Limited, Rugby.

Africa World Press, Inc.
P.O. Box 1892
Trenton, New Jersey 08607
(609) 695-3766

CONTENTS

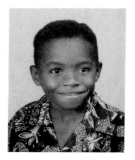

1953

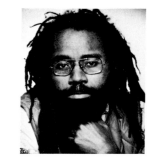

1988

Armet Francis is today a major photographer. He began working as a professional photographer in the late 1960's covering fashion, advertising and reportage. His work has been widely published in journals including 'Time' magazine, 'West Africa', and 'The Sunday Times'. He has also worked on documentaries for the BBC and Channel 4. 1974 saw his first one-man exhibition at the Commonwealth Institute. His work has been exhibited in Nigeria and the Caribbean, as well as London and New York. His most recent exhibition was at the National Museum of Photography, Bradford.

Djibril Diallo was born in Senegal, West Africa. He obtained a BA in Linguistics from the University of Dakar followed by a PhD in Linguistics from the University of London. Mr. Diallo has held various senior positions at the United Nations including Chief Spokesman for the UN Famine Relief Office; Information Officer for Africa at the UNDP; Special Assistant to the Director of Africa Bureau of the UNHCR. Mr. Diallo was also Assistant Director of the International African Institute in London and is currently Senior Adviser to the Executive Director of UNICEF in New York.

INTRODUCTION

In 1984 Africa went through the worst famine in recent history. 150 million Africans were directly threatened by hunger and starvation; 10 million were displaced, living in overcrowded refugee camps, shanty towns, or just roaming the wilderness looking for something to eat. 3 million people did actually starve to death. Little known to many outsiders is the fact that three-quarters of the 150 million, three-quarters of the 10 million, three-quarters of the 3 million were children and women. They are the most vulnerable sector of the community. They are defenceless. And they are the first to suffer in times of hardship. They are children like Ethiopian Zelleke, a little Ethiopian girl/refugee whose desperate mother rushed to me when I arrived at a refugee camp called Bati, in Northern Ethiopia. The mother thrust Zelleke's emaciated body into my arms. She pleaded with me to take her little girl with me so that she might survive but, to my horror, Zelleke died in my arms a few moments later. We heard about and we even experienced first-hand deaths of children like Zelleke because they are part of what we call *'loud emergencies'* at UNICEF – those natural disasters like droughts or earthquakes that catch the world headlines. Unfortunately there are many more deaths that occur away from the glare of television cameras or journalists' lenses, deaths whose only witnesses are the parents of the deceased. They occur, day to day in Africa, Asia, the Caribbean, Latin America and elsewhere. These are in fact 'silent emergencies' of global proportions, emergencies which this Introduction will explore in a continuing effort to eliminate them.

When my friend, Armet Francis, asked me to write an introduction to his latest book I hesitated a little bit, Armet has a knack for performing wonders through the eye of his camera. No subject is too complex, for his sharp eyes, as amply demonstrated by his previous published work. But for me to summarise in words the state of children, African and non-African, from places as far apart as Dakar, Senegal, Addis Ababa, Ethiopia, and Kingston, Jamaica, can be a daunting task for many reasons.

I gladly accepted, however, because we all need to support Armet, each in our different ways, in his noble endeavour to strengthen links between Africans and peoples of African descent, wherever they are in the world. Armet's book is particularly striking because, through the vibrant faces his camera captures, he brings us a message of peace and hope in today's troubled world. That hope is embedded in those whom Armet has chosen as the subject of 'Children of the Black Triangle'.

All sorts of phrases are used to stress the importance of children for the future of any society. But, regardless of the language one uses, one of the most shameful facts of life today is that, each year, l5 million small children, including 5 million in Africa,

are killed from the combination of gross poverty and gross underdevelopment. Millions of children died last year, millions died the year before and at least the same number, 15 million, will die this year and next year. Even more shameful is the fact the majority of such deaths need not happen. They can be prevented very easily and cheaply as stressed by James Grant, UNICEF's Executive Director; 'these children do not die from exotic causes requiring sophisticated cures. Five million of them die in the stupor of dehydration caused by simple diarrhoea. More than 3 million die with the high fevers of pneumonia. 2 million die marked by the rash of measles, a million and a half die racked by the spasms of whooping cough. Another million die with convulsions of tetanus. And for everybody who dies, many more live on in hunger and ill-health'. Such deaths stem, not from the consequence of loud emergencies mentioned above, they are part of the 'silent emergencies': Mothers who are illiterate; water that is dirty; lack of adequate health facilities and so on. Silent emergencies are exacerbated by 'loud emergencies'.

What can you do?

Armet Francis is an example of how an individual is getting involved to make a difference for the future of our children. And we hope that, in response to Armet's call for action, many more people will get involved, each one in his or her own way. It is for these reasons that I am outlining some means through which you too can get involved by encouraging a vigorous response to the needs of children.

Low-cost means exist today that can go a long way towards preventing such large-scale deaths. The techniques have been developed by UNICEF into what is known as the Child Survival and Development Revolution (CSDR). They are based upon a combination of technological breakthroughs and intense social communication efforts. Commonly referred to as GOBI, such techniques stand for Growth Monitoring, Oral Rehydration Therapy, Breast feeding and Immunisation. Summarised below is how such techniques can make CSDR possible. (See Appendices i & ii.)

Djibril DIALLO
Senior Adviser to the
Executive Director
UNICEF New York, USA

REASONINGS

The knowledge of ancient societies has always influenced newly emerging nations. It is now commonly accepted that Africans created and developed great kingdoms imparting knowledge in the sciences, architecture, philosophy, astronomy, mathematics, and the arts, which directly influenced the development of other cultures.

Trade in commodities such as gold, copper, cloth and spices between Africa and Europe was transacted on mutually agreed terms. Europeans destroyed this principle and laid the foundation for the overt exploitation of Africa and its people.

In 1492 Spain financed a Genoese explorer, Christopher Columbus, to find a new trade route by sea to the East. The success of this journey would depend on the 'new theory' that the world was round. [At the first sighting of land Columbus presumed he had reached the Western coast of India which is today called the West Indies!]

This discovery introduced settlements of Europeans to the Americas. The rapid colonisation of the New World was the start of a new Plantocracy. A key factor in the expansion of these plantations was to be the use of the indigenous people, i.e.; the Amerindians, as a labour force. This proved to be unprofitable with their rapid depletion through disease and overwork.

Subsequently, the need for a source of cheap labour led to the the exploitation of African people for the continued expansion of the plantations in the Americas. This began the start of the Atlantic slave trade which, over a period of 400 years, institutionalised over 100 million African people into chattel slavery. The estimated loss of life caused through capture, revolts, and the 'middle passage' is estimated at two thirds of that 100 million. The young and strong were preferred to maximise profits.

This created the wealth that secured the development of European world domination. After the so called emancipation from slavery in the 1830's the Europeans resolved their conflicts over ownership of Africa at the Berlin Conference of 1884/ 5 and decided to divide the continent among themselves. This final division, restructured the boundaries, the names, the laws, the education, the economics, the politics, the religions and the use of land. This monopolistic control ensured the continuation of Africa's underdevelopment and created a triangular diaspora of Black peoples. The Black Triangle is then a very complex yet simple state that started through the use of slave labour. For me 'the triangle' starts in Jamaica in 1945 in the Santa Cruz

mountains, a community of Africans, Indians, Chinese and Europeans, a community more or less self-sufficient, with enough to market for future development. They were hill-farmers, very much isolated from the developments of the twentieth century. One of its few influences from the outside world was contract work on the plantations in Cuba and Florida.

By the end of World War II, the need for cheap labour intensified in Europe and in Britain. This was *the opportunity* for my people, to find *work in the motherland.* In response to recruitment, a migration started to take place to the post war cities of Europe and to America, with countries such as Britain importing citizens from its Commonwealth to form a part of their labour force. The masses were not aware of the numbers of black people who were annually to fill the menial workspaces. The elite of course knew very well the continued demand for this cheap labour. This process would not have taken place in today's socio-political climate.

This is not a unique situation, for us: what is unique is our fight for freedom and the necessity to regain our rightful autonomy in the world. Taking that position as correct, it then becomes necessary to give credit to the individuals and groups of our people who have contributed to this direction. The revolutionary spirit which created our heroes and heroines began in childhood.

Our children are a celebration of the beauty of innocence. They possess the total experience of their people. All that has taken place will one day be expressed through them. I would like to celebrate the children of the African diaspora, and in so doing, the children of the world. I would like to say to the exploiters, to their conscience, to look at themselves for what their kind are doing to children. It is now necessary for them to stop.

It is necessary for our children to evolve beyond mere avengers of our past, to be motivated by more than action and reaction, to take a positive direction. The simple matter of everyday learning, survival, understanding a world more or less governed against them, that's hard enough, to expect the ultimate clarity. Looking at what has been perpetrated on the children of the diaspora, we would conclude a judgement of genocide. I would say to Europeans: learn how they have achieved their position in the world, and who they have oppressed in so doing.

The psychological effect of slavery on African people, and the understanding of that history, dictated the conditions of the future, of a people in exile and bondage.

So of what importance is this presentation of today's reality? I would contend that the vast majority of black people's positions in the world today is due to the effect of European exploitation. The ultimate future of a people depends upon the well-being of its children. Children are the key to nationhood, to the direction of the future.

Let us consider today's children in the 'Black Triangle'. They are engaged on the frontlines in the struggles against the repression of their peoples. Less obviously, they are victimised by political control agents such as 'the state's penal systems.' Here the statistics prove that they are the prime targets.

The Protagonist or Antagonist in the struggle for dominance is the state, whose systems of oppression, laws and weapons are directed at our children. It must strike fear in the hearts of those in power of whatever persuasion, for them to send their armies against defenceless children. You would agree that South Africa is a prime example. If we look around at our own position you will see it in relative terms as the same war.

Take the attribute of innocence, naivety, and let us look at these two in the process of wisdom. What if it was possible to take the child in this concept and perceive a situation where the evolutionary process is uninterrupted. In other words, take away the child and the innocence and then continue the cycle of accumulated information. Can we preclude we would be the wiser? In other words, eliminate the doctrine of the individual. Or is it that the balance of the child gives us the position of humility, the position to see our own mistakes. Surely we are allowed to make too many mistakes, present too many excuses so we can say we have not yet learned. We have not been taught, so we hide in the naivety of innocence, we commit many wrongs, using that position. We also use the child to give justification to our existence – our reason for being. What if the child had the ability to reason in the context of evolutionary wisdom, yet retain the growth of innocence.

Armet Francis

THE JOURNEY

Winston sat bolt upright. He was sweating again. 'Phew,' he said to himself and looked around the cabin to see if anyone had noticed. Everyone was asleep as far as he could see, 'can't let anyone know that I'm terrified' he thought. He'd been having these dreams ever since he'd been on the boat. It was the first time he had been on a boat; first time he's ever seen the sea! 'Ah, yeh, but I can't let them know really' thought Winston, Why was he frightened of the sea? Why was he frightened of cabins? It seemed to have been inherent, the fear.

He laid back on the bunk and tried to sleep, a humming bird flashed into his thoughts hovering just above a flower in very vivid colours, I think they called it a god bird. Now there was a more powerful sound. The throbbing of the engine room. It got louder and bigger and more massive. He shivered a little. The sound of the waves. Just two feet below the porthole. Supposing it came through the glass. Everyone would be drowned. His shiver turned to sweat again.

Trying to sleep had become a nightmare since he'd got on this massive metal structure called a ship. He'd never seen one before, but he knew there was something to fear.

A little tear came to his eye but strong images of his grandmother, standing on the wharf looking up at him on the bow of the ship, obviously crying, were somehow comforting.

He was a big man now – he was going to England! To see his mother and father. He was travelling a long way on his own, in a big ship. Well, almost on his own. He had a guardian, Kupi, but they had separated him from her because, they said 'he was a man now, too big to be in the girls' cabin.' He was eight. Shocked at first, and then angry. 'I suppose they were right 'cos I would have looked.' So he was put with the men. Some of them he knew; most were old enough to be his father. Now he had to deal with them, so he couldn't show that he was frightened at all.

Lincoln had become Winston's mate and was looking after him. They might have been related in some way; they came from the same village. He hadn't taken much notice of him before but now he was a friend. Lincoln had travelled to America. Although not the eldest, Lincoln seemed more aware as to what was happening in this movement of Jamaicans, mostly poor, small mountain farmers some of whom had been to Cuba to work on the plantations and others to the munitions factories in America,

contracted for the war effort. You could tell the ones that had been on contract work, they seemed confident but a little weary. The others seemed gullible, innocent of what the future held. 'They were going to work, weren't they? Gold on the streets of London, Birmingham, the Motherland? Yes, of course.'

'Come man, get up!' A loud voice woke him from what seemed like a long, long night. Oh! how long is it going to take to get to this place! He was on his own now, everyone else had gone upstairs. The sun was shining through the porthole; he pulled up a box to stand on so he could see the waves with the light bouncing on them. It was calm, so different from the night, the anger and power that seemed so overwhelming in darkness.

Darkness does have a power. Enough of this! He yawned, stretched, had a quick wash and went upstairs for breakfast. The food was a bit funny, not what he was used to. He'd seen and eaten more different foods in the last week than in the previous eight years put together and that was a long time, eight years. That's what he thought anyway. He knew how to ride a donkey, how to plant yams, coco, corn, callaloo, how to collect the eggs from the chickens. How to pick and dry tobacco with his grandfather, how to walk 5 miles to school, and a lot more, but he was completely lost on this metal thing in the sea! There were these toilets with water that came out of metal pipes. 'I suppose this ship gets the water from the sea, 'cos they must use a lot!' Maybe he wasn't so big after all, maybe he didn't know anything!

He stepped out into the passage, there was no one, so he ran up the stairs and onto the deck and took a deep breath, stretching his body and looking at the sea. It didn't seem like this boat was moving; it seemed to be floating in a pond. He thought about Christopher Columbus, whom they had taught him about.

A hand sat on his head 'Y'alright boy? Betta gwan eat some food, instead a dreamin' the world is round' he said to himself as he walked off towards the big dining room, 'Yeh, it is round', 'cos if you look round the ship, you can see for miles, and doesn't matter how fast it goes, it never gets to the end', Oh anyway, that's in books isn't it? He'd forgotten how much noise came from the dining room, almost as loud as the engine room, if not louder, there wasn't just one noise there was a whole heap, he felt even smaller, so many people.

He screwed up his face and went towards a friend that he'd met. 'I wonder if Janet is thinking the same things; oh, anyway she's with her mother and her big sister.' They had almost finished eating their breakfast. So he got in the queue. Still staring at Janet and her family. He looked around for Lincoln and when he caught sight of him, Lincoln was already looking at him with a wink, and a big grin on his face. Oh that was a good feeling. He was feeling warmer now.....

'What would you like?' broke into his thoughts. He'd never seen so many white people before, in fact he'd only seen one, and Lincoln said these were Spanish people. 'Spanish,' he thought, not English, so that's what history must mean. The Spanish and before them Arawak Indians, Caribs, and then the English! But he didn't look like any of them, they didn't mention him in any of their books. Oh wait a minute, the Africans, 'Gwan! Gwan, Sah!' he must have been holding everyone up again.

He didn't know where to go and sit now. There was Kupi, his guardian, but she was one of the girls now, and there was Janet. The choice was made easy for him as Lincoln and the boys were calling him over, he felt quite big, but a bit disloyal to his other friends. 'I'll see them later anyway, plenty of time on this boat'. He didn't even realise what was on his plate until he sat down. It was egg and bacon, that's what Lincoln said. I know what egg is and bacon must be hog's meat, how do they cut it so thin?

Lincoln said, 'Y' all right man? You look like you did a gwan sleep all dey. D'ye ave a hard night?' He looked up at Lincoln suspiciously, 'No, when we got up this morning you didn't budge so I figured man must 'ave had a hard night last night y'know, but we all do sometimes.'

Hmm, Lincoln seemed to know things that other people didn't, but I'm sure, he was asleep. 'No man, he must 'ave worn himself out playing with Janet and dem,' entered another voice.

He wanted to ask Lincoln so many things, but then, a young lady called him. Lincoln turned away, 'Speak to ya lata man.' Winston was alone again. He ate up his food and ran over to Janet who was at the front of the ship with Tony and her big sister Janice. He had to speak about different things to children and he felt so much older than them. They were all excited about something, looking over the front of the boat into the sea and screaming, 'Look at that one! Look at that!' What could

they be looking at? The boat was going very fast. What could keep up with it? He ran over to see. 'Let me see man, lemme se wa-a gwan?' But before he could look. 'Be careful, come away from there,' Oh no, it was Janet's mother. 'We'll be careful! We'll be careful,' he said. He had to stay and look but first he had to control this grown up, 'Come up and see, come up and see now Mrs Brooks.'

She came over reluctantly but was just as fascinated as the children; she wasn't much older. They all peered over again, this time with authority. And there, glistening right in front of them, was a group of 20 or 30 magnificent dolphins, gliding along in pairs. As they looked they floated away one at a time. It was the most amazing thing he'd ever seen! Everyone was silent now, it was their little secret for a short time.

There were only two of these beautiful fishes left now, it was like a game they were playing — maybe they were little boys and girls as well! The noise started again, 'who's going to win?' who's going to win?' when it became obvious that it was a race 'my side, no my side!' and then quick as a flash there was only one and it looked majestic and larger as it was now right in the centre, about a foot away from the bow. There was a slight quiver in the fish's back and it was obviously getting tired and Winston hoped it wouldn't be too brave and get hurt. Then, voof! Quick as a flash, it was gone! The children looked at each other in astonishment, their hearts pounding very fast. Someone said 'Aw, that's nothing, I saw a flying fish yesterday!' Then Winston remembered his grandfather had said to look out for the flying fish just between Jamaica and Cuba, 'and mek sure y'don fall in the sea boy'. His grandfather had been to Cuba to cut cane 'fe mek money', im seh 'you can mek good money'.

'Well ee must 'av mek money bekaws he had a house and ting and a kitchen and a horse and lots of things,' but Winston hadn't seen Cuba yet. He had visions of sailing past a big plantation, on the end of an island. 'Wow, a lot's happened today already, and the day hardly begun!'

He turned around, and there were lots of people on the deck walking and talking and playing games, the sun was hot. ['Honk!'] it was the ship's horn. He looked up, his eyes resting on one of the big chimneys. There was a big wheel and a man in a white uniform standing behind it. 'Look Janet! that must be the driver,' Janet's big sister said 'That's the Captain,' 'No,' said Winston 'that's the driver, like the one in market truck.' She sucked her teeth and said, 'This is a ship and he is called a

Captain.' He felt a bit silly, but couldn't argue, she must be right. 'Anyway, there must be lots of Captains 'cos there's another one down there same as him.'

Janet's sister pulled her away, 'Come on, he's an idiot!'

He felt angry, so he walked up to the man in the uniform, he had seen them before but wasn't brave enough to ask. 'Excuse me are you the driver, or are you de Captain?' The man looked down at him and seemed a little bit puzzled. He asked again.

'Ahh! No, I am not the Captain, I am the Purser,' in his funny accent and walked by.

Now he was even more confused.

Winston walked with lots of thoughts towards the back of the ship, and sat down behind a big pulley. This was his secret spot. He could see but not be seen. His mind went back home, watching his grandfather in the butt'ery. 'Come man, lay out the leaves for me. We have a whole heap of cigars to make today.' His job was to separate the leaves and sprinkle water on them to make Havana cigars. The butt'ery had a strong smell of tobacco and glue. It was fascinating to see the growing process from seeding to maturity, the drying and the building of the cigar. 'What gonna happen to the cigar then?' 'Dem will go to the shops in Kingston and Havana, maybe all over the world. Me na know really but me get good pay for dem.' He could always ask questions. One was right on his lips but Rahmon was very engrossed. 'Pass me some more leaves.' He was important in the process of production. He was getting dizzy now because of the strong smell of tobacco. 'Let's stop for dinner now,' said Grandfather.

That was welcome. Saturday was a day for doing lots of things on the farm. Granny had cooked saltfish, ackee and yam. When they had finished eating, Granny said, 'You can come and help me pick some tomatoes, dem soon ripe. We have fe tek dem to market in Santa Cruz before dem spoil.' He looked at Rahmon and got a nod.

'Tek de mule,' he said. 'Let's go and saddle up with de big hamper.' Granny lifted him up on the seat and they rode off up the track towards the field about half a mile away. He jumped down and tied up the mule. Granny called him over, 'Put de straw hat on for de sun. You mustn't pick the green ones but de ones that are nearly ripe.' They had to get to market the next morning at six o'clock.

Now he was going to meet his mother and father after five years.This was going to be the most exciting time of his life. They had faded into dream people; now it was only a matter of minutes. The train was slowing into the station. All about were getting themselves ready, putting on big coats, big hats, after three weeks on a boat. No one seemed to mention how cold it was, or maybe it was too much of a shock, or realisation of a dream come true. All the human interaction that three weeks together on a ship had brought, friendships had been made. But for most they were going their separate ways. Meeting old friends, husbands, wives, sons, daughters, into a bright future in the motherland. 'Boy it cold,' came loud and clear over all the clamour. It stopped everyone for a moment, it seemed to give freedom to express the reality that we are all in this together.

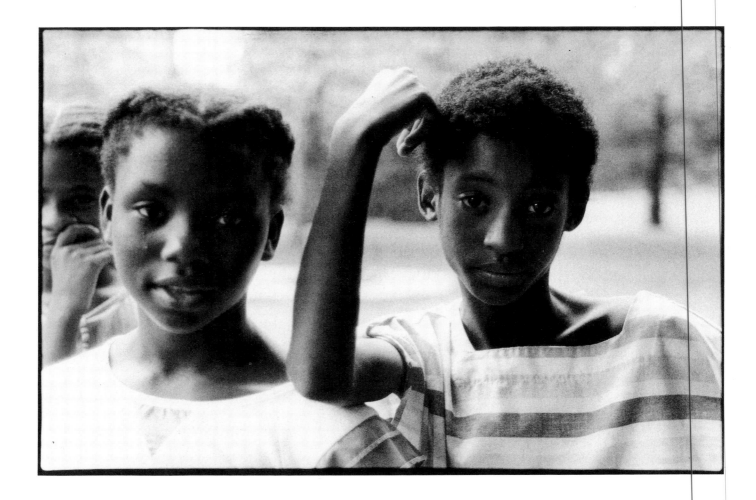

Summer camp. New Jersey, USA. 1986

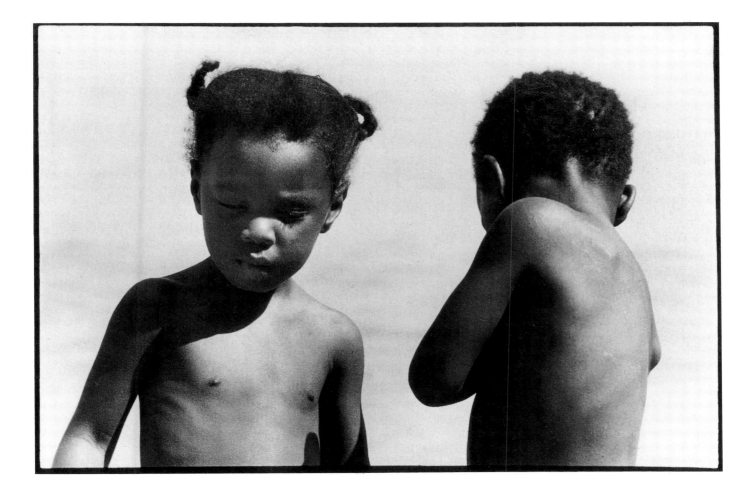

Day at the seaside. Hastings, UK. 1983

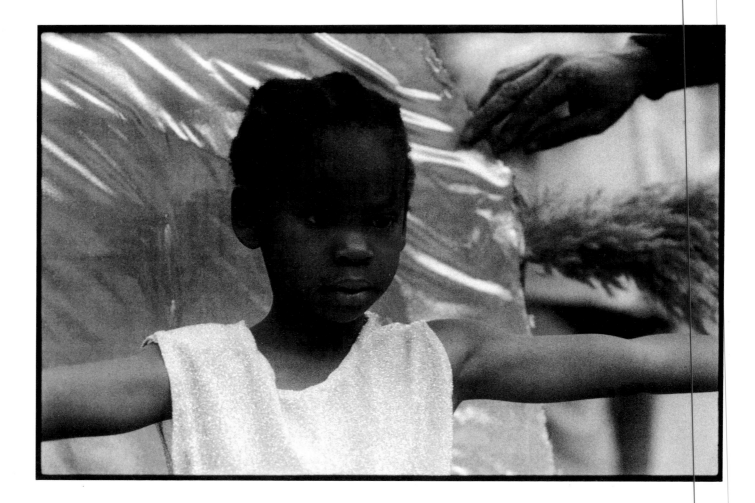

Carnival. London, UK. 1981

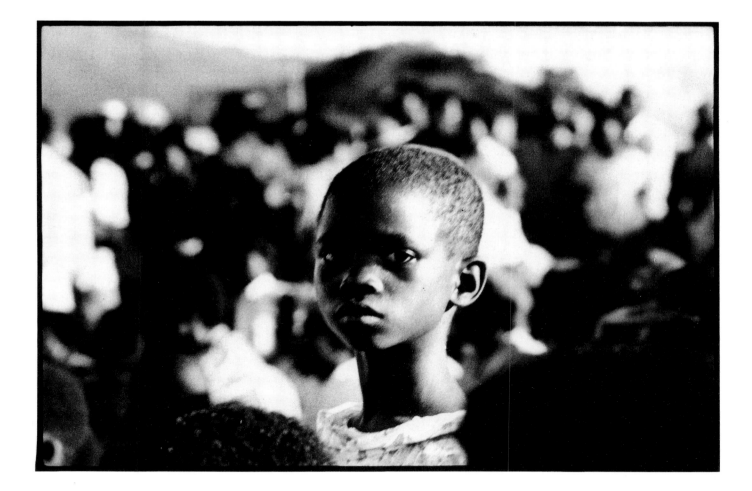

Kenya. 1980

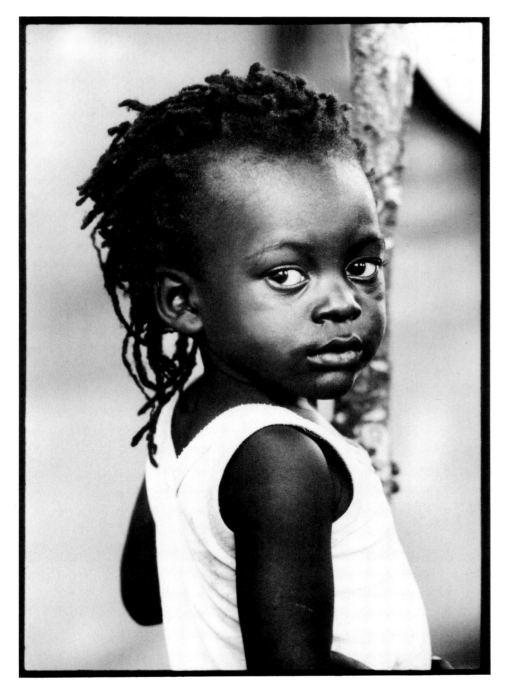

Rasta child. Bull Bay, Jamaica. 1980

THE NEVER ENDING POEM

In the land of peace
Oh will you shine
Or will thou dull the golden fleece
I know not what you mean
Lest you forget, lest you forget
We are in the land of our masters
We are in the land of our exploiters
We are in the land
For we fill their prisons
Lest we forget
As our youth fill their prisons
Lest we forget the masters of tokenism
The masters of
Yes we might believe our state of independence
Our homeland is not in any sense
Lest we forget
As we share the spoils of their exploits
Lest we forget
As we fill their mental institutions
Lest we forget
As they criminalise our revolution
Lest we forget
As we push another button
You know in the land of Techno
Lest we forget
In the land of robots
The need for us will rust....
Lest we forget

John Coltrane
Alice Coltrane
Alexander Pushkin

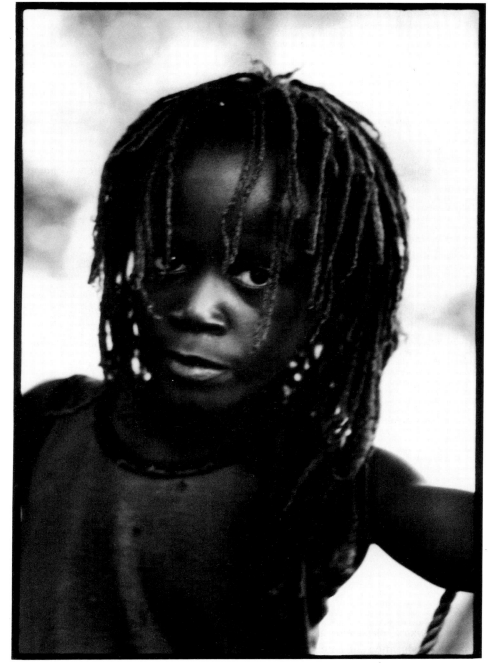

Lest we forget
Jack Johnson
George Padmore
George Washington
Carver
Berry Gordy Jnr.

Lest we forget
W.D.Handy
Scott Joplin

Lest we forget
Blind Lemon Jefferson
Harold Moody
Paul Cuffee
Samuel Coleridge Taylor

Lest we forget
Celestine Edwards
Henry Sylvester Williams
I.T.A. Wallace Johnson
Gary Sobers
Learie Constantine
Alexandre Dumas

Kingston, Jamaica. 1980

THE RIGHTS OF THE CHILD

(Declaration adopted by the United Nations November 20th 1959)

Principle 1

The child shall enjoy all the rights set forth in this Declaration. All children, without any exception whatsover, shall be entitled to these rights, without distinction or discrimination on account of race, colour, sex, language, religion, political or other opinion, national or social origin, property, birth or other status. Whether of himself, or of his family.

Principle 2

The child shall enjoy special protection and shall be given opportunities and facilities, by law and by other means, to enable him to develop physically, mentally, morally, spiritually and socially in a healthy and normal manner and in conditions of freedom and dignity. In the enactment of laws for this purpose the best interest of the child shall be the paramount consideration.

Principle 3

The child shall be entitled from his birth to a name and a nationality.

Principle 4

The child shall enjoy the benefits of social security. He shall be entitled to grow and develop in health; to this end special care and protection shall be provided both to him and his mother, including adequate pre-natal and post-natal care. The child shall have the right to adequate nutrition, housing, recreation and medical services.

Principle 5

The child who is physically, mentally or socially handicapped shall be given the special treatment, education and care required by his particular condition.

Principle 6

The child, for the full and harmonious development of his personality needs love and understanding. He shall, wherever possible, grow up in the care and under the responsibility of his parents, and in any case in an atmosphere of affection and of moral and material security; a child of tender years shall not, save in exceptional circumstances, be separated from his mother. Society and the public authorities shall have the duty to extend particular care to children without a family and to those without adequate means of support. Payment of state and other assistance toward the maintenance of children of large families is desirable.

Principle 7

The child is entitled to receive education, which shall be free and compulsory, at least in the elementary stages. He shall be given an education which will promote his general culture and enable him on a basis of equal opportunity to develop his abilities, his individual judgement and his sense of moral and social responsibility, and to become a useful member of society. The best interest of the child shall be the guiding principle of those responsible for education and guidance; that responsibility lies in the first place with his parents. The child shall have full opportunity for play and recreation, which should be directed to the same purposes as education: society and the public authorities shall endeavour to promote the enjoyment of this right.

Principle 8

The child shall in all circumstances be among the first to receive protection and relief.

Principle 9

The child shall be protected against all forms of neglect, cruelty and exploitation. He shall not be the subject of traffic, in any form. The child shall not be admitted to employment before an appropriate minimum age: he shall in no case be caused or permitted to engage in any occupation or employment which would prejudice his health or education, or interfere with his physical, mental or moral development.

Principle 10

The child shall be protected from practices which may foster racial, religious and any other form of discrimination. He shall be brought up in a spirit of understanding, tolerance, friendship among peoples, peace and universal brotherhood and in full consciousness that his energy and talents should be devoted to the service of his fellow men.

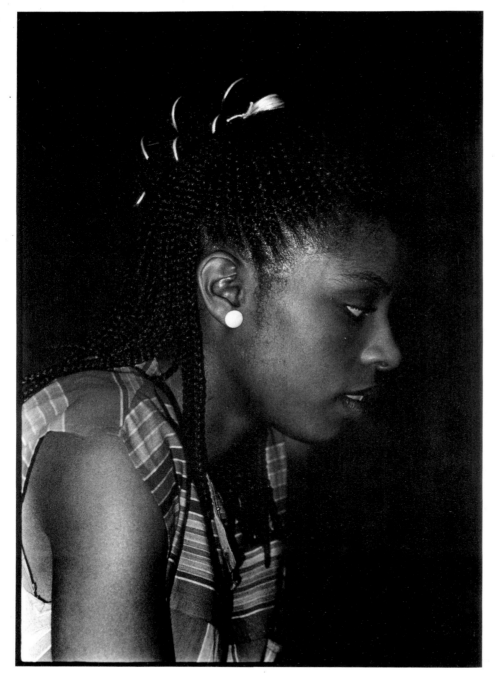

Lest we forget
Cetawayo
Francis Williams
Robert Wedderburne
William Cuffay
Ignatious Sancho
Francis Barber

Lest we forget
Marcus Garvey
Harriet Tubman
Martin Luther King Jnr.
Malcolm X
George Jackson

Lest we forget
Louis Armstrong
Phyllis Wheatley
Imhotep
Nelson Mandela

Lest we forget
Mary Secole
Winnie Mandela
Paul Bogle
Toussaint L'Overture
Kwame Nkrumah

London, UK. 1985

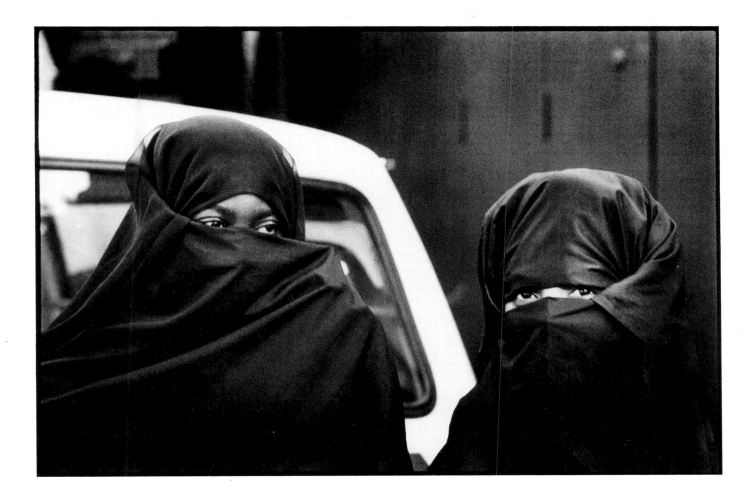

Dakar, Senegal. 1976

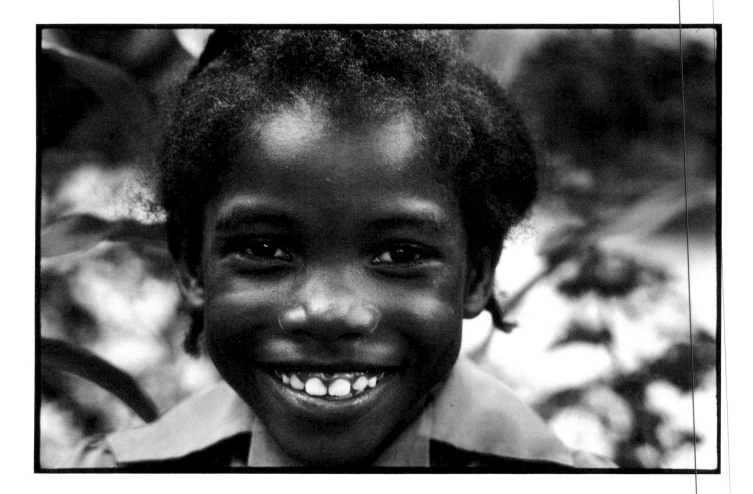

Kingston, Jamaica. 1980

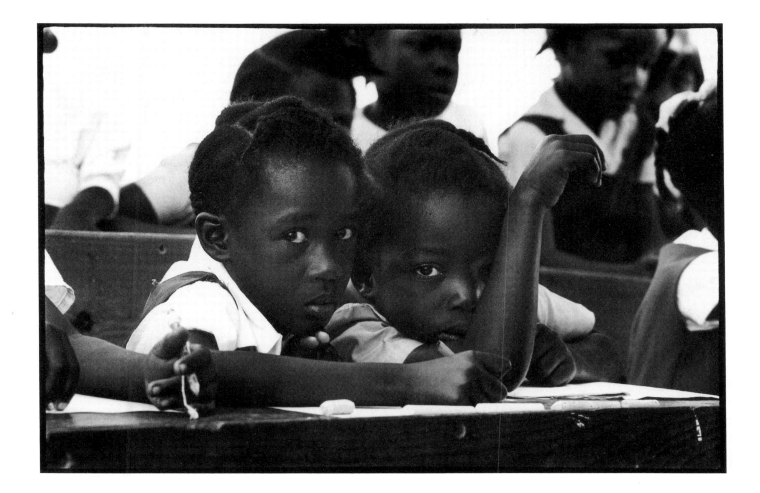

Classroom outside Fruitful Vale, Jamaica. 1980

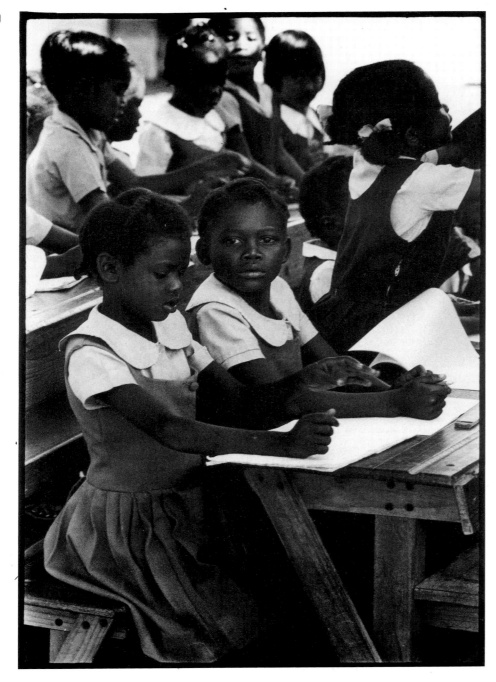

Lest we forget
Patrice Lumumba
Shaka
Haile Selassie
Bob Marley

Lest we forget
Charlie Parker
Angela Davis
Hannibal
Josephine Baker

Lest we forget
Billie Holliday
Steve Biko
Mahalia Jackson
Miriam Makeba

Lest we forget
Nina Simone
Alice Walker
Aretha Franklin
John Lee Hooker

Lest we forget
Muddy Waters
Harry Belafonte
Julius Nyerere
Jomo Kenyatta
Robert Mugabe

Fruitful Vale, Jamaica. 1980

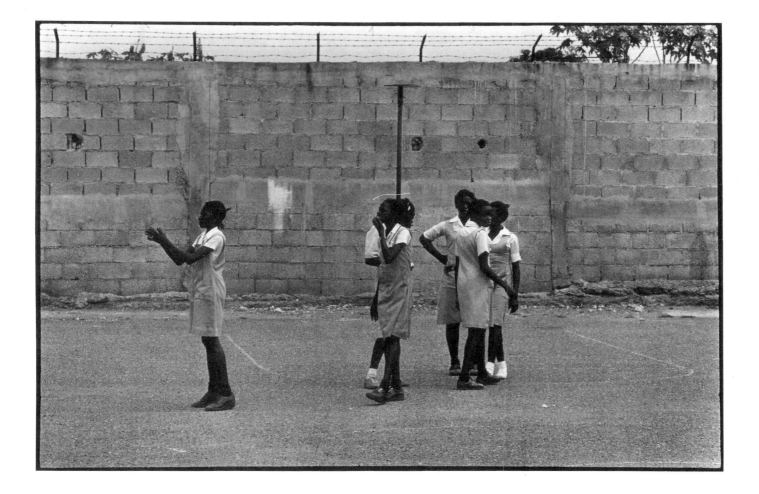

Break time. Fruitful Vale, Jamaica. 1980

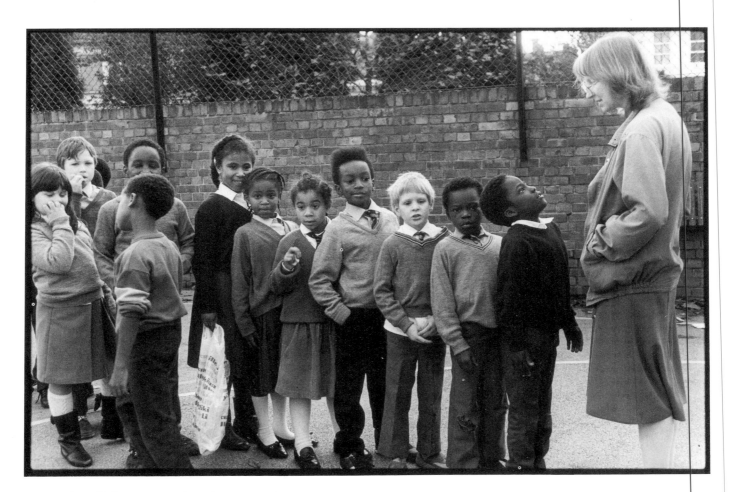

MARCUS GARVEY (at fourteen) 'At fourteen my little white playmate and I parted. Her parents thought the time had come to separate us and draw the colour line. They sent her and another sister to Edinburgh, Scotland, and told her that she was never to write or try to get in touch with me, for I was a ''Nigger''. It was then that I found for the first time that there was some difference in humanity, and there were different races, each having its own separate distinct social life.' I asked, 'Where is the black man's Government? Where is his Kingdom? Where is his President, his country, and his ambassador, his army, his navy, his men of big affairs? I could not find them, and then I declared, I will help to make them.'

Lining up after school break. London, UK. 1987

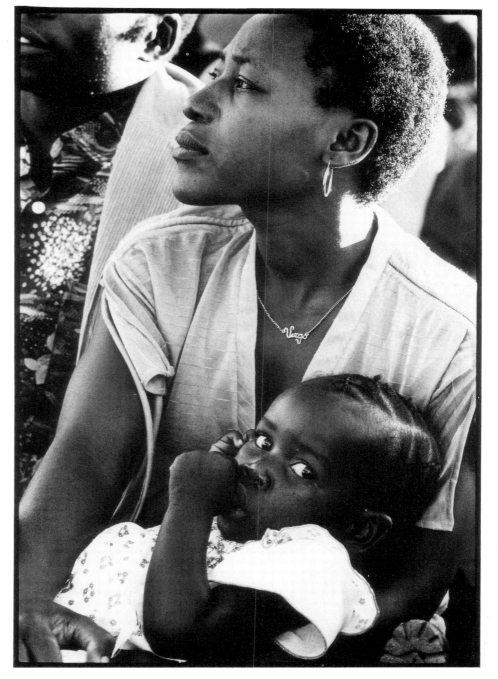

Lagos, Nigeria. 1977

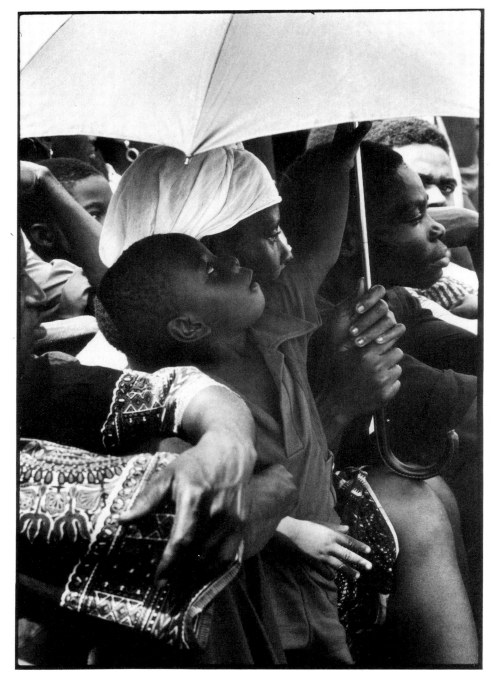

Lagos, Nigeria. 1977

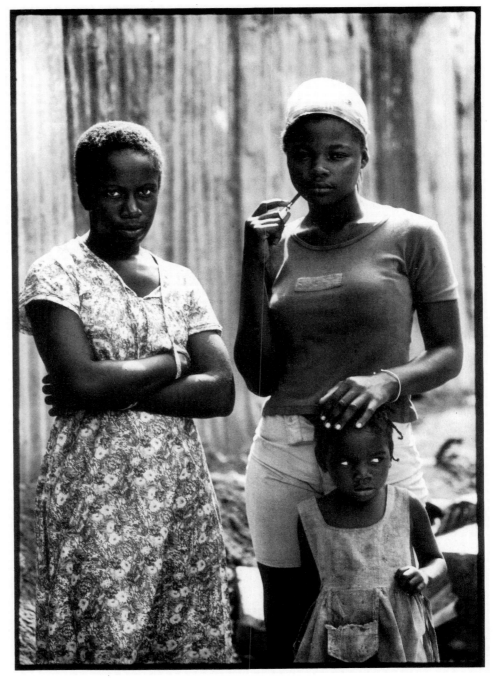

Kingston, Jamaica. 1980

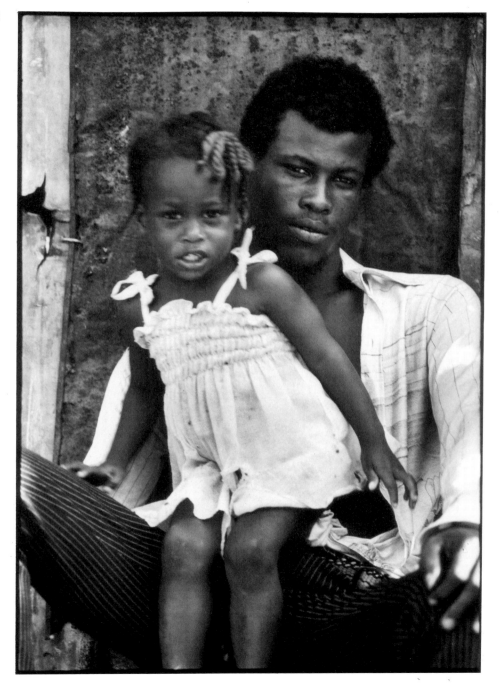

Father and daughter. Kingston, Jamaica. 1980

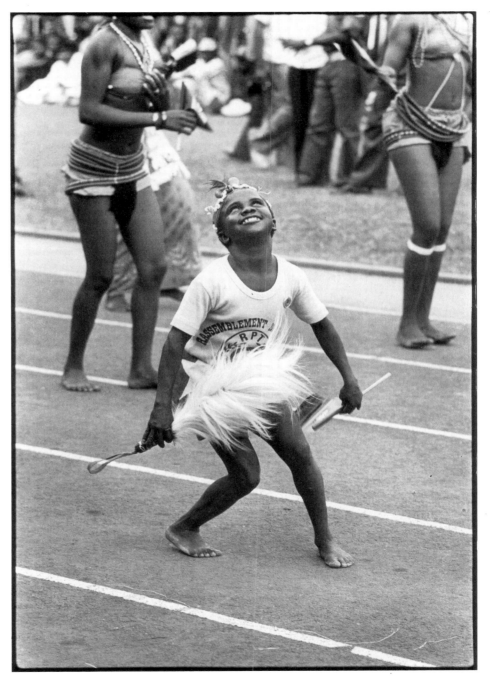

Performance at 'Festac' National Stadium.
Lagos, Nigeria. 1977

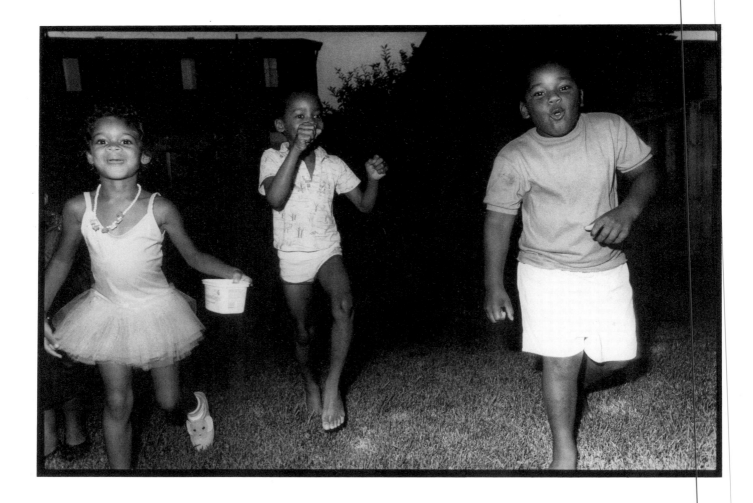

Racing game. Scarborough, Toronto, Canada. 1986

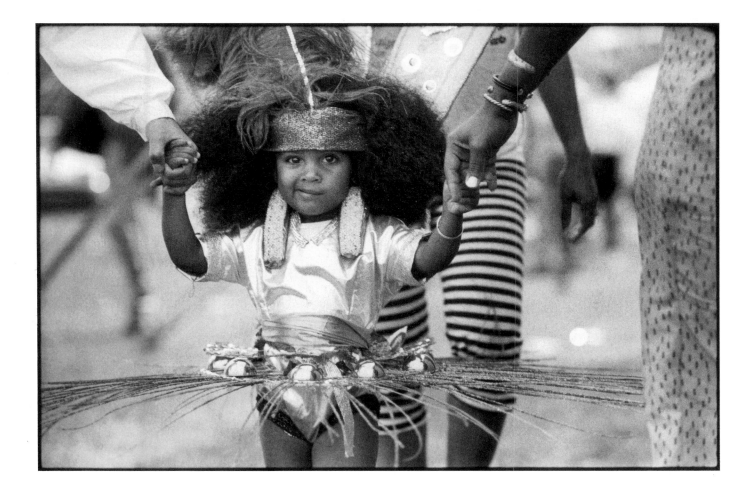

First carnival. Playing Mass. London, UK. 1986

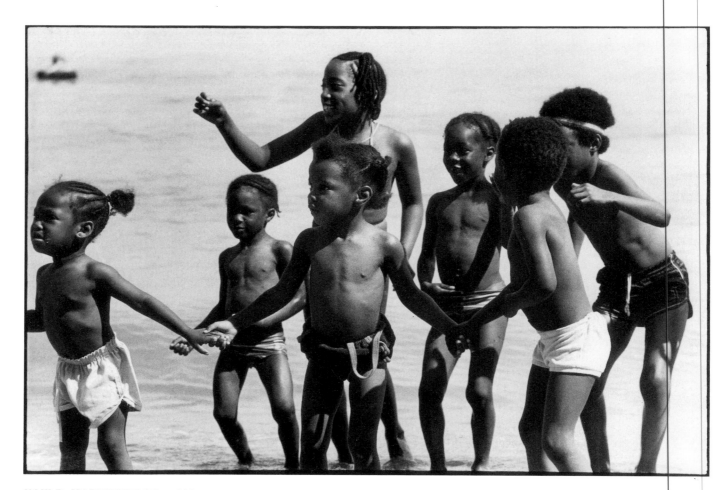

HAKI R. MADHUBUTI 'The middle passage was the key turning. The ocean was a destroyer; a supreme separator of body from soil, spirit from soul, mind from source. What I am questioning is, can you imagine the pain? Pain greater than limbs severed in an automobile accident; pain not unlike nails driven into the heart. What happens to the mind that in one second is in command of one's own destiny, free to work, build, play, love and make use of one's creative juices; and in less than a blinking eye one is reduced to a number on a sea captain's ledger, refined out of the human family, diminished to a state of personal property to be sold worldwide as a slave.'

Day at the seaside. Hastings, UK, 1983

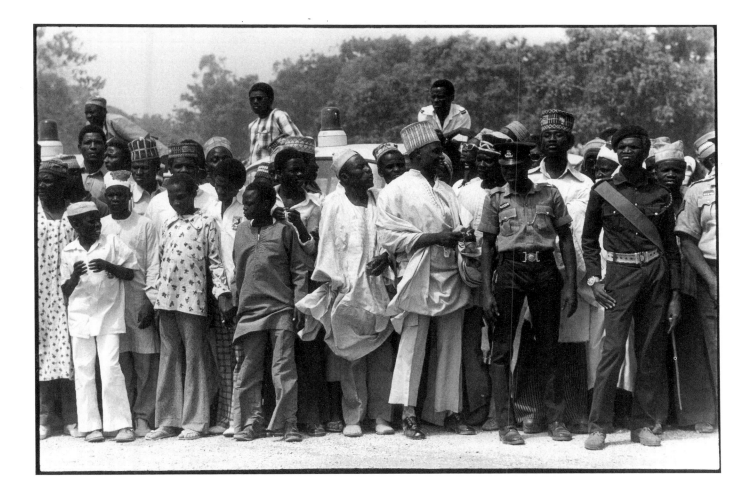

Watching the Derba. Lagos, Nigeria. 1977

WALTER RODNEY 'Many African rulers sought a European ''alliance'' to deal with their own African neighbour, with whom they were in conflict. Few of those rulers appreciated the implications of their actions, they could not know that Europeans were out to conquer not some but all Africans. This partial and inadequate view of the world was itself a testimony of African underdevelopment relative to Europe, which in the late 19th century was itself confidently seeking dominion in every part of the globe.'

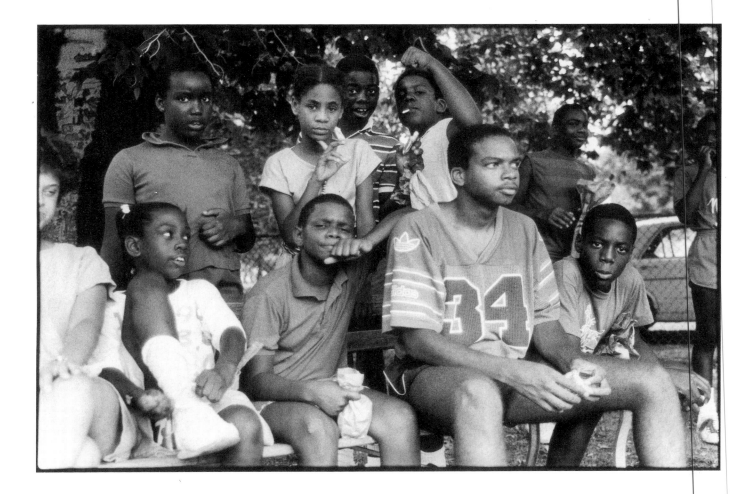

Summer camp. New Jersey, USA. 1986

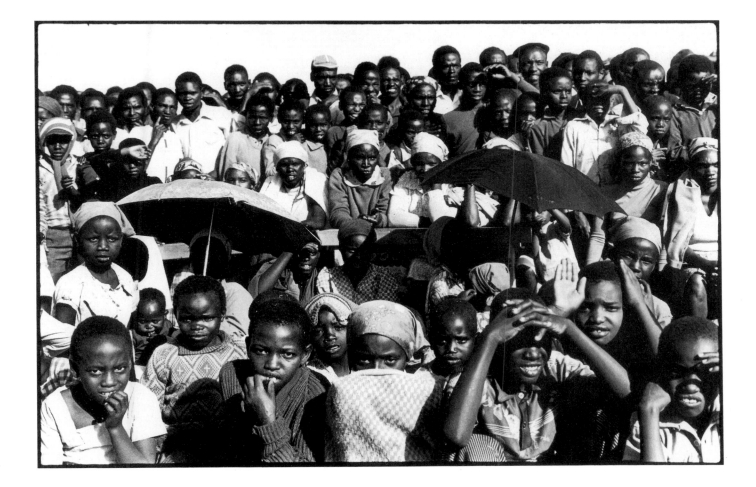

Watching cultural performance. Kenya. 1980

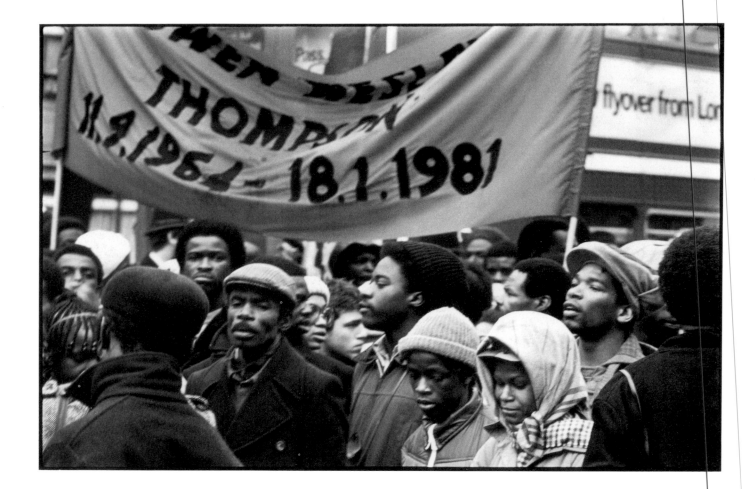

WALTER RODNEY 'So long as any African society could at least maintain its inherited advantages springing from many centuries of evolutionary change, then for so long, could the superstructure continue to expand and give further opportunities to whole groups of people, to classes and to individuals.'

New Cross march for children who died in fire. London, UK. 1981

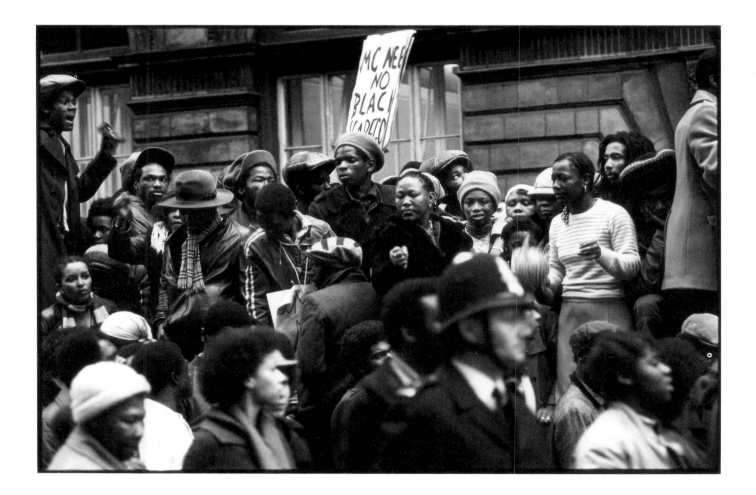

London, UK. 1981

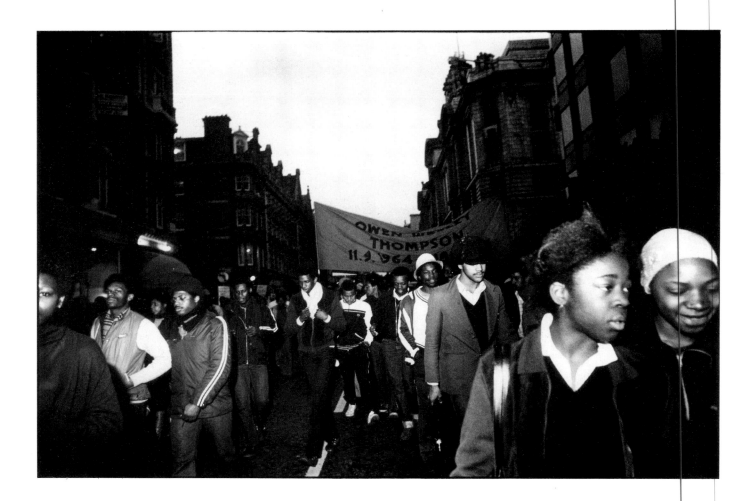

London, UK. 1981

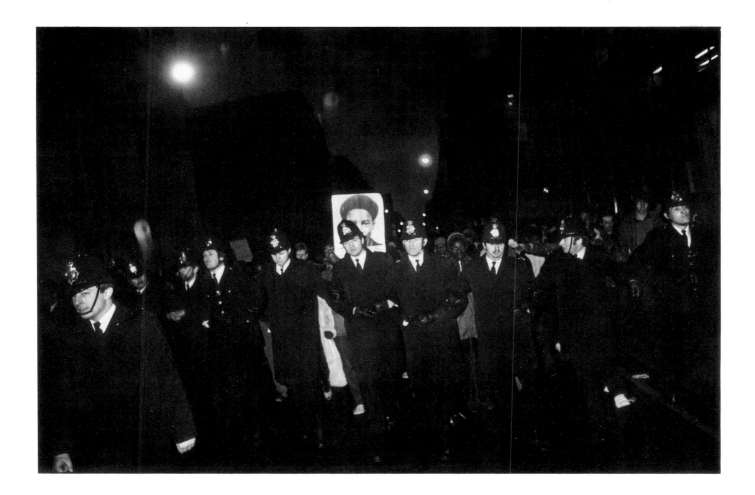

London, UK. 1981

WALTER RODNEY 'Pervasive and vicious racism was present in imperialism as a variant independent of the economics that determined that Europe should invest in Africa and control the continent's raw materials and labour. It was racism which confirmed the decision that the form of control should be direct colonial rule'.

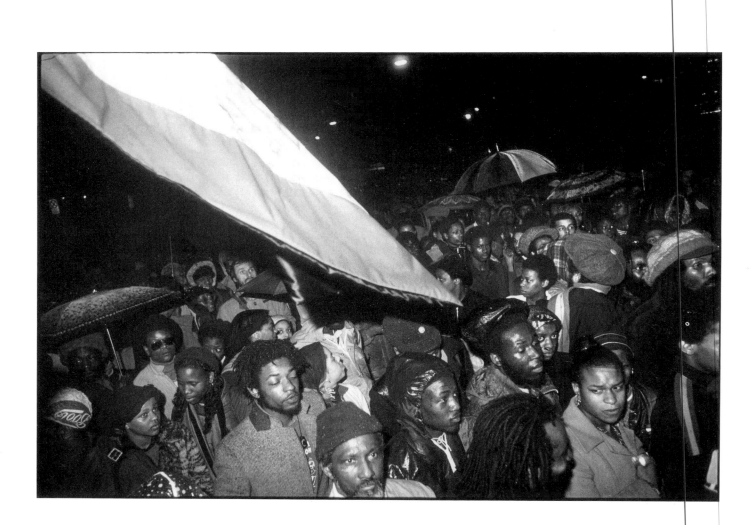

London, UK. 1981

INTERVIEW IN EUROPE

Tell me about your childhood and when you came over here, starting from where you lived in the Caribbean?

Well, it started a long time ago, coming to England. In the sense that my mother came here when I was three so I've always wanted to come here. When my mother sent for me I was eight, and that's a long time for a child to wait to see his mother. Of course children have illusions about what they're walking into. I'm talking in retrospect, so I really have to go back to my childhood understandings to give you the truth. England to me was my mother, and I remember there was somebody called the Queen or something, so there were two people I was going to meet, and my father of course.

What happened when you arrived?

Well it took a long time to arrive here by boat, we should have landed at Southampton, but they literally dumped us off in Portugal where we had to continue our journey by train. Forcing us to run across what seemed like an endless web of trainlines. I've got this amazing vision of people's suitcases and hats, clambering through hale with a rainbow as a backdrop. Coming from the mountains of Jamaica in 1953 to an urban European situation was a massive culture shock for me: I used to talk with a Jamaican accent, until I went to school in Bermondsey, Docklands. It was there I discovered that if you're going to survive with children, you've got to speak their dialect, so the first thing I had to learn was how to speak Cockney. If you take your own language and you have to get rid of it, a conflict of identity comes in straight away, but at that age you're not aware of what you're doing. In a negative way this country made me conscious of colour and being black. I've since come to realise that a lot of people's feelings are dying that way; rather than dealing with love, hate seems to be the priority, and I went through stages of transferring my energy into that space.

Explain to me how you feel about the camera, or photography?

The camera has the ability to do what we cannot do, which is to stop a moment, that we can all look at and form judgements, 'a reflective understanding'. The reason I came into photography is to do with the fascination of seeing images. I think everyone has a fascination about images. Because we like to look at each other and ourselves.

Do you mean you're into self portraits?

I'm not talking about the narcissism, of images of self; I'm talking about the fact that we are all children fascinated by images.

Let's talk about the work you're doing with children

Children have an innocence which overcomes. We learn from each other, and if you stay with that principle you can find the really basic energy that transpires right around the world; that's what I see, that's what I look for in children. I mean some children have already grown through their childhood. You can see it, but there is an innocence with clarity that children have. They don't have prejudices unless they've been presented with them. There is a certain quality, and it's nothing to do with age, it's something that I look for and you'll probably see that in some of my pictures. Innocence but not naivety is what I look for.

What about when you're doing photography with them in a workshop?

Children are very visual, they will look at you and decide very quickly what you are, who you are and where you're coming from; and then they will either go away or come towards you. Then you have a dialogue. That's when it starts to happen. It's really communicating with each other. If I have a little bit to give them, then it's beautiful. That's really what it's about, that's really what I'm into. Like I said, it's nothing to do with age. It's to do with a conscious energy.

How do you explain that to the kids?

You don't have to, when you're really communicating with children you don't have to explain things like that. What they want to find out is how you play, are you fun?

When you're going out to do your pictures, if you go to a place and take your camera how, do you work? Is everything posed or grabbed?

There's a respect which is very necessary for me when I take photographs, because I feel that the camera is a massive imposition on people's existence. You can either walk into a situation and feel that you can work, and not impose; or there are certain times when you have to reason with people. Reasoning is an understanding of trust that the images you are going to capture will be used correctly, and you can either do that through the eyes, or just the way you are. I mean people can just look at you and say 'Ah, a person I can trust' or not, and when you travel it's more evident.

Can you just tell me about what I've got to see?

If you look at my work and you see that all the images are black, and you say to yourself, 'I can only relate to these people to a certain degree because they're not my colour or my race', then you are completely missing the point. The point is that I'm just presenting my pictures as a format to say something to the world. If you see them simply as black people then you have closed yourself off from the common human condition, which is not just for black people you only have to go out in the street and see that it's a common human condition we're looking at. That's fundamental to my work.

Tell me how the realisation came to you that you were black?

As I have said previously, coming to this country, the culture shock, it made me aware that I was black and that meant something negative, to be not quite as good, not quite the same; people make you aware of that.

Was there a link between that and your decision to go back to the Caribbean. What made you think, I must go back?

For me to become aware that I should go back to the Caribbean is a natural progressive instinct of what has been presented to me. If you're not accepted, simply as a person, as a human being, everyone will move back to where they know there is love and understanding. So it happens naturally if you are brick-walled all the time.

Tell me about going back to the Caribbean?

I didn't understand that I needed to go back to where I was born. I understood the media, fashion, advertising, that's how I learned my trade. But I got to the point where the work that I was doing didn't mean much to me. I had very few images of my own people, so I felt I had to go back and start taking pictures which I considered to be socially conscious, that opened my eyes to the wider colonial impositions on black people.

What was your impression when you went back, after such a long time?

I very quickly realised that I had an illusion of Paradise, and it was necessary to get rid of that in order to see what was happening. I saw callousness in a naive state, in the sense that people did not have the global information about what was really going on. They thought their problems started when they could not get enough water to grow their food or get enough money to buy their tools. What can you grow in the mountains? All the best land is still owned by plantation owners 'To be poor is relative; you're poor when someone tells you, and you believe it'. The problem that arrived in my community was when that realisation occurred. When they're told there is more, and the human instinct is for more.

What were the good things that you saw? What did you want to celebrate with your camera?

I saw people functioning very simply. Again, the first picture I took was of children; they were free enough to allow me to communicate. I photographed in the market places; there is no pretention there, everything is up front. That's where I learned about life with my grandmother. It took me a whole day, wandering around, but it was necessary.

When you go into a market, what are you actually looking for with your camera?

I'm looking to capture a moment in time, an honest feeling, an honest space, a simple truth. I followed that principle in Africa and America.

*Could you just give me an idea of what you're trying to say in the **Triangle**?*

Coming here has made me and a lot of black people conscious of the world, because slavery has distorted our understanding of what the world was about. Africa was stopped in those slave ships, not in the cultural and spiritual sense, which could never be taken away, but that basic connection with the rest of the world was stopped, severed. I saw that in the Caribbean, then, I had two equations to deal with. I thought there must be a triangle, a pyramid. Seeing what I'd captured in my pictures, my next stop was Africa. Hence the triangle came into being.

The triangle is?

The triangle is: The Americas and the Caribbean, Europe and Africa. The black triangle, for me, is a very deep feeling, politically, culturally and socially one that is to be presented in a simple way. I had to capture it through my camera, through my work, and to present it as honestly as possible. From that I hope a few people will be able to understand what I'm saying: that a wrong has been done to my people, and if you see it, maybe in one picture — the quiet suffering, the happiness and all the human feelings — then that shows that it exists. That's what I hope to achieve.

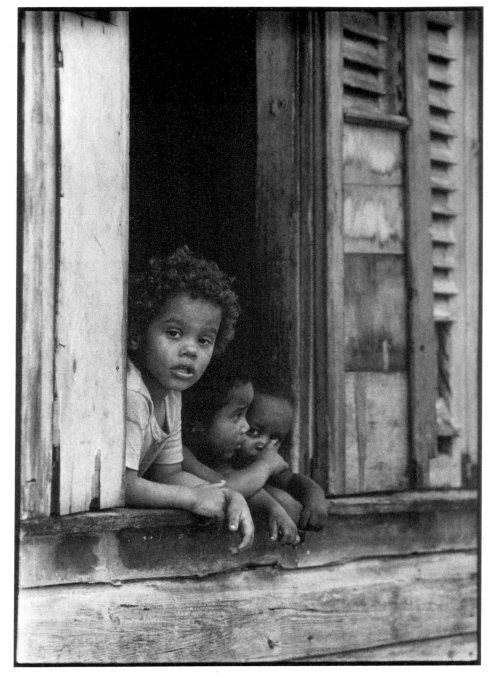

Lest we forget
Michael Jackson
Miles Davis
Stevie Wonder
Jessie Jackson
Wole Soyinka
Bill Cosby

Lest we forget
Eddie Murphy
Sidney Poitier
Maya Angelou
Bessie Smith
Duke Ellington

Lest we forget
Ella Fitzgerald
Cleopatra
Nefetari
Sam Cooke
Pele
Charlie Byrd

Lest we forgot
Alex Hayley
Art Tatum
Sunni Ali
Count Basie

Watching procession at 'Carifesta', Barbados. 1981

Lest we forget
Pope Victor 1
Dick Gregory
Queen Nzinga
Crispus Attucks

Lest we forget
Olaudah Equiano
Sojourner Truth
Benjamin Banneker
Frederick Douglas

Lest we forget
Emperor Theodorau II
Josia Henson
Manu Dibango

Lest we forget
James Baldwin
Cheikh Anta Diop
W.E.B. Dubois
Franz Fanon
C.L.R. James

Lest we forget
Walter Rodney
Paul Robeson
Gwendolyn Brooks
Huey P Newton
Zora Neale Hurston

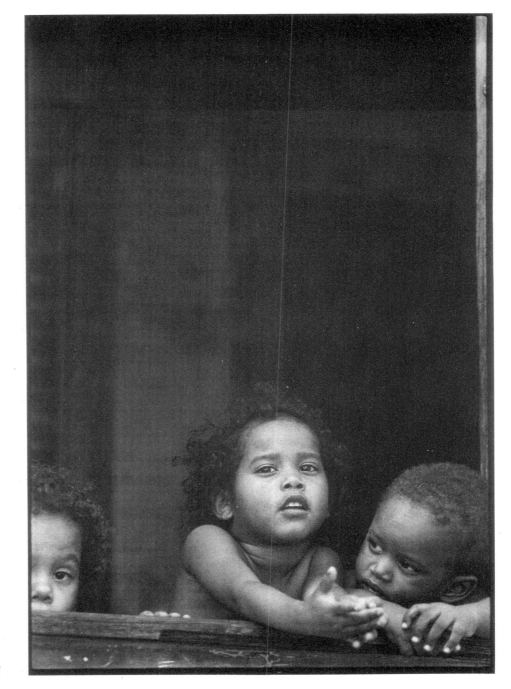

Barbados. 1981

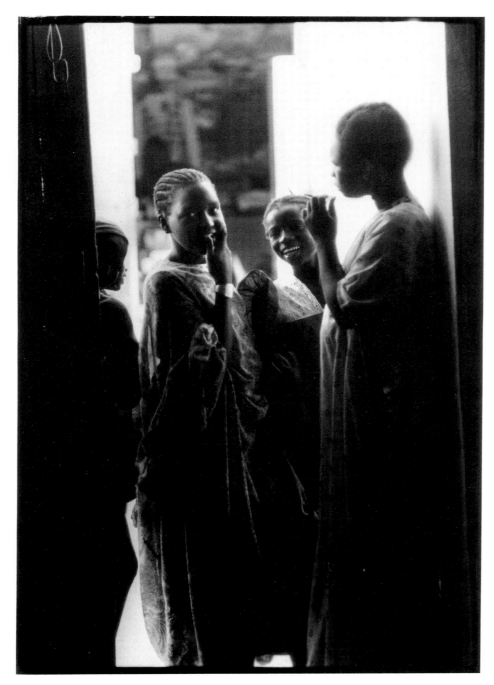

Lest we forget
Langston Hughes
James Brown
Fela-Kuti
Sunny Ade
Coretta King
Queen Mother Moore

Lest we forget
Jessie Owens
Muhammed Ali
Toni Morrison
Chinua Achebe
Norman Manley

Lest we forget
Bustamante
Sam Sharpe
Diana Abbot
Field Marshal Muthoni
Ciceley Tyson
Lena Horn

Lest we forget
Kwame Toure
Chuck Berry
Bo Diddly
Taj Mahal
John Handy
Althea Gibson

In conversation. Dakar, Senegal. 1976

Lest we forget
Paul Boateng
Bernie Grant
Pope Melchiades
Bishop Tutu
Bunny Wailer
Matanzima

Lest we forget
Nat Turner
Arthur Gudrup
Sun Ra
Richard Wright
Sammy Davis, Jr
Yvonne Goolagong

Lest we forget
Pharoah Necho
Aesop
Sappho
The Mahdi
Abi Bekele
Josiah Tongogara

Lest we forget
Gongo Mussar
Mwanamutapha
Juan Latimo
Saint Benedict
Mebo Changamire
Osei Tutu
John Chavis

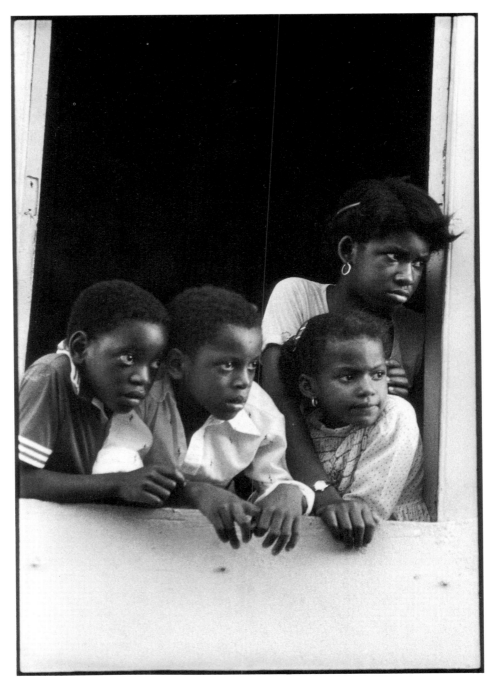

Watching procession. 'Carifesta', Barbados. 1981

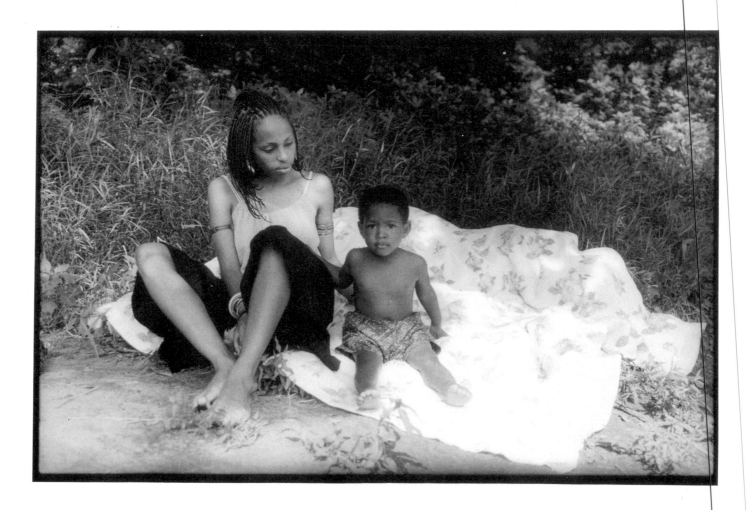

Picnic by the river. New Jersey, USA. 1986

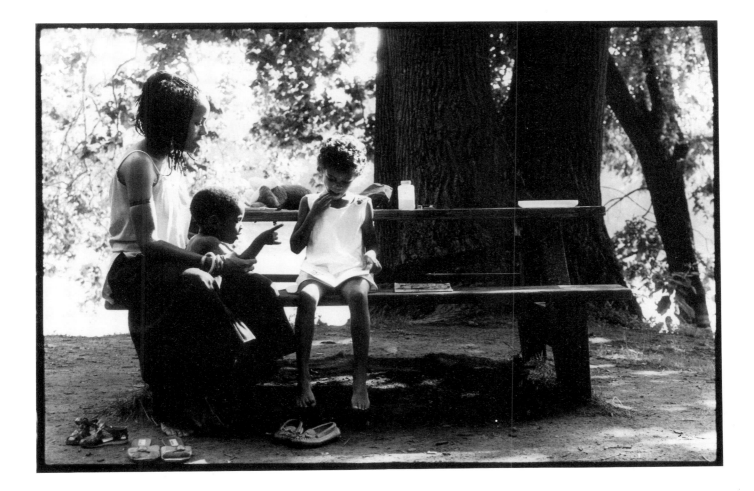

Reading in the park. New Jersey, USA. 1986

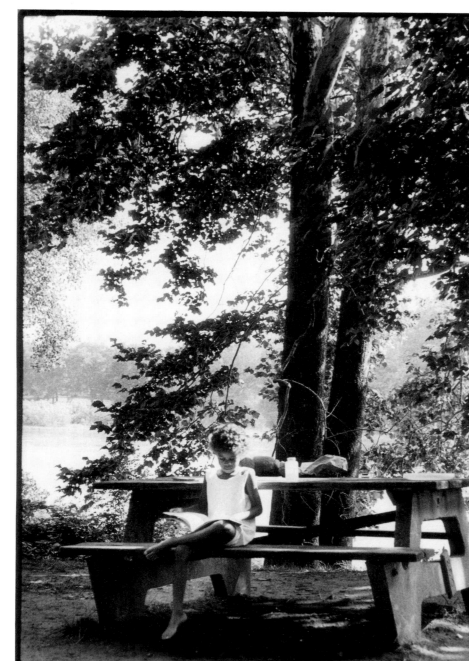

Lest we forget
Williams Wells Brown
Auguste Lacaussade
Fraunces Tavern
John Baptist Philip
Peter Randolph

Lest we forget
Tobias Barreto
Chancellor Williams
Samora Machel
Aime Cesaire
Imamu Baraka

New Jersey, USA. 1986

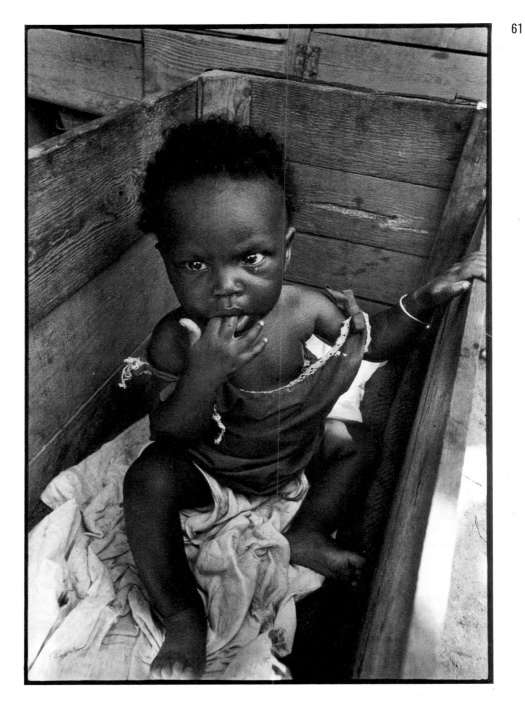

Child in cot. Kingston, Jamaica. 1969

REASONINGS SLAVE MARKET

Here is another recurring thought;
You are my slave; property
I have paid for you;
I hope you understand the principle.
Then you will not question your position.
Because your choices are limited.

Here are some of my rules.
I own you totally; you are in fact not human.
You are chattel, but you must not act like one.
You must be able to carry out my commands.
But not question them.
You will work for me,
You will not be paid,
You will not have a name,
Only the one I give you.
You will not speak your mother tongue.
You will not create families.
You must not rebel.
You must produce more workers.
We have a stud farm.

I hope you understand so far.
I will take your chains off,
When I have broken your spirit.
I know you will wish to survive,
So you will not take the easy way out.
So the brutality of my command will be total.

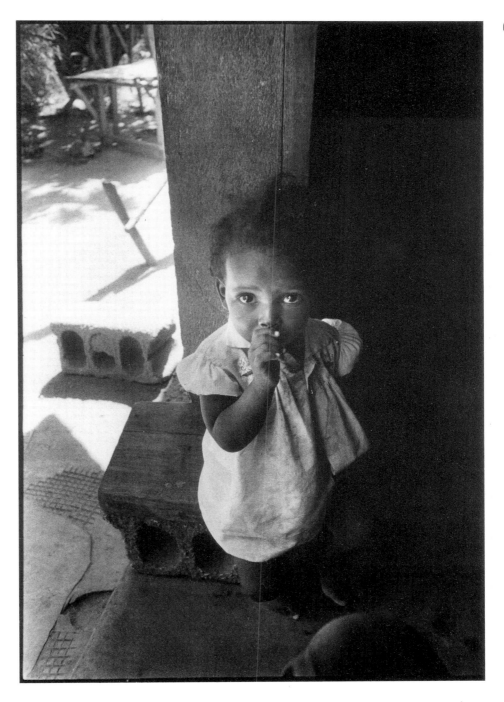

A little bit sad. Kingston, Jamaica. 1969

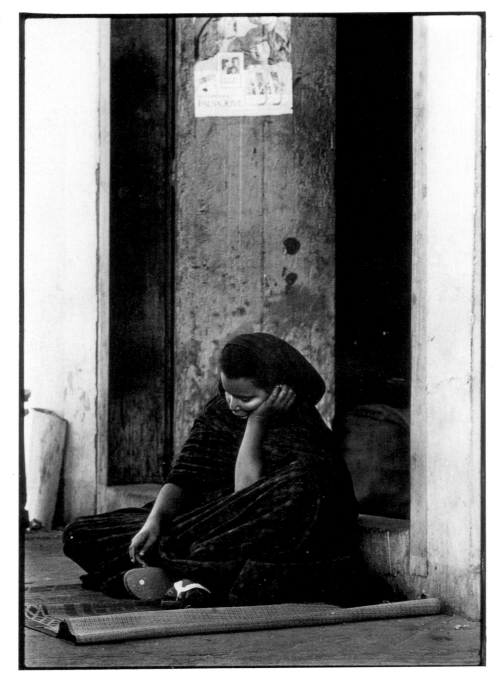

Contemplative mood. Dakar, Senegal, 1976

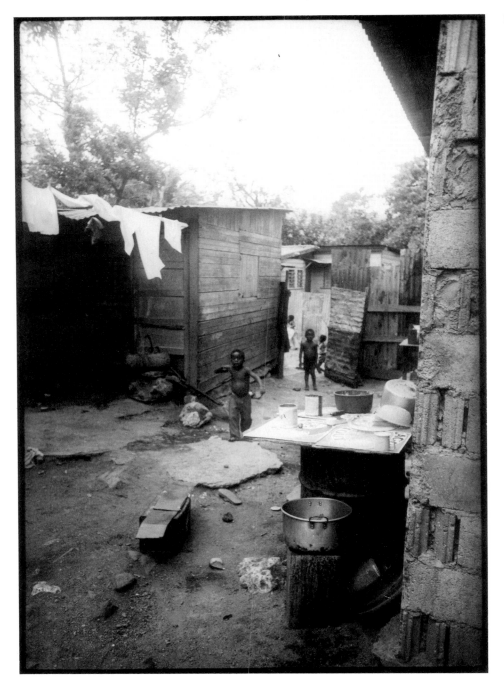

Back yard. Kingston, Jamaica. 1981

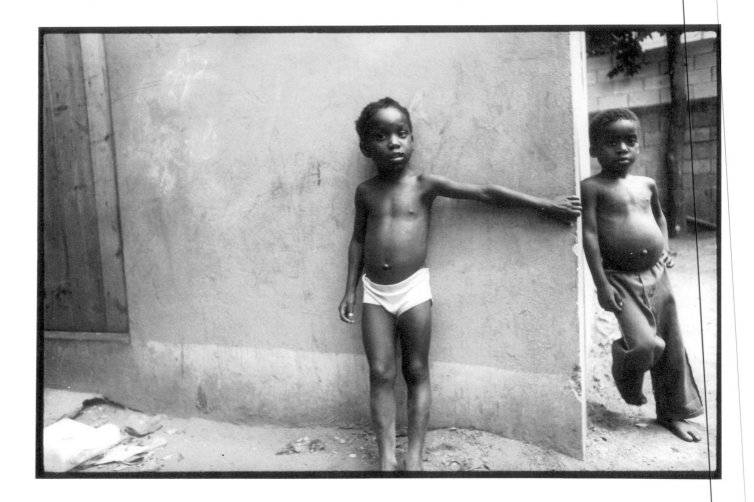

At play. Kingston, Jamaica. 1981

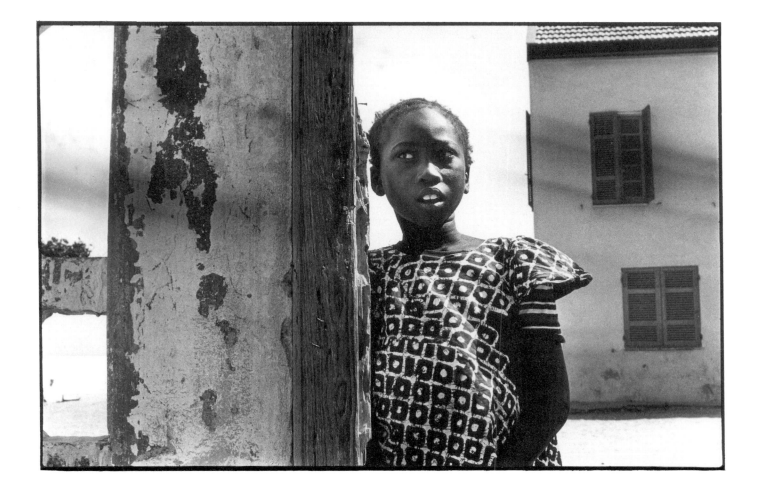

Watching. St. Louis, Senegal. 1976

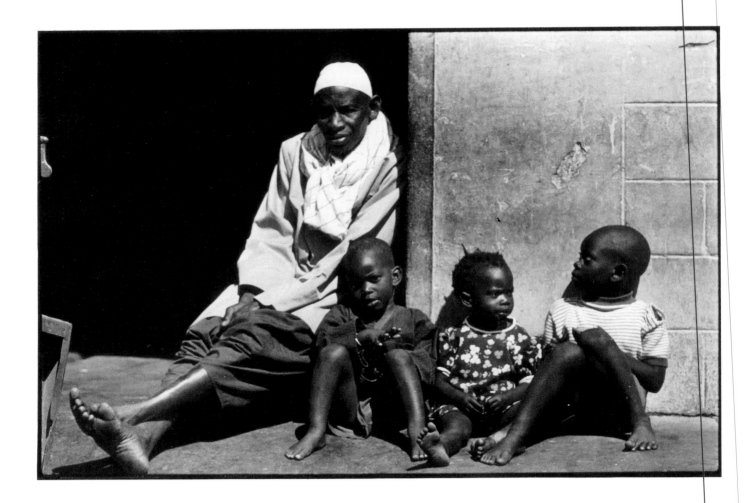

Taking a rest. Dakar, Senegal. 1976

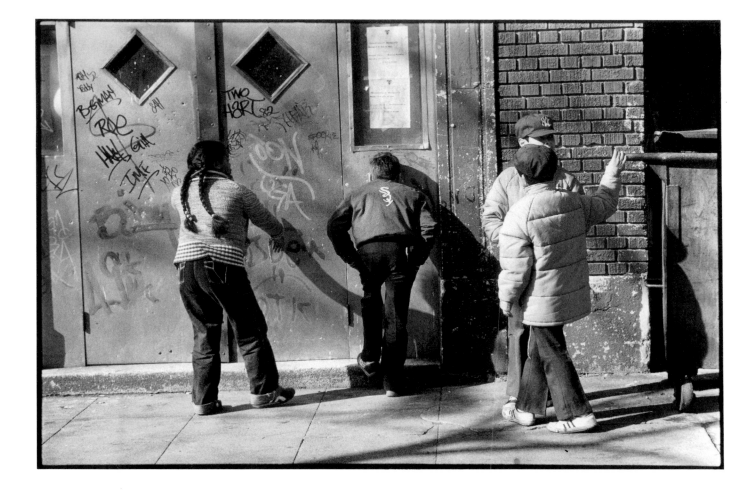

Peeping through the door. Harlem, USA. 1981

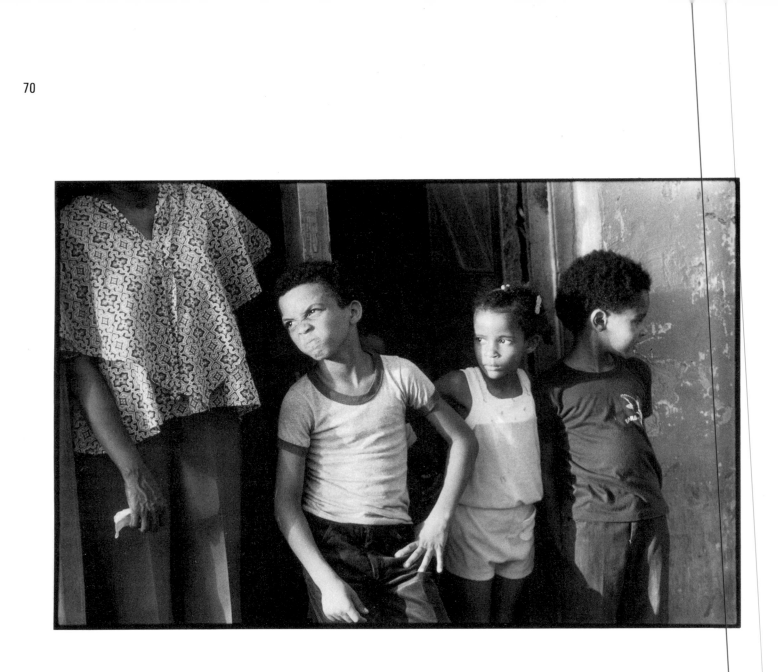

Checking it out. Harlem, USA. 1981

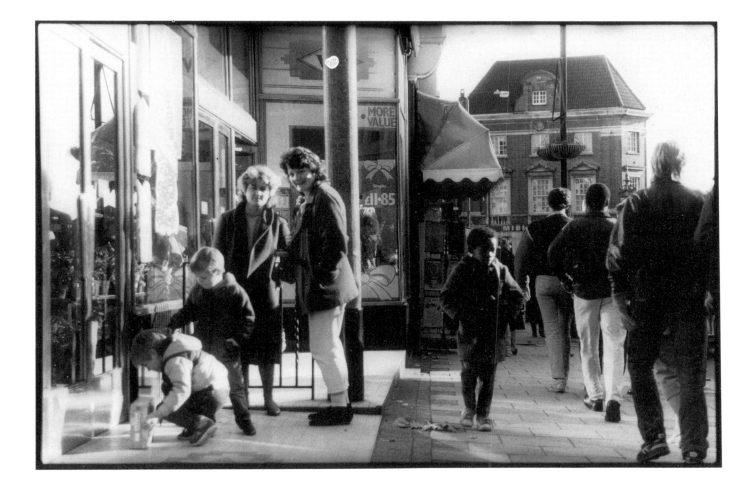

Shopping day. Harlesden, UK. 1986

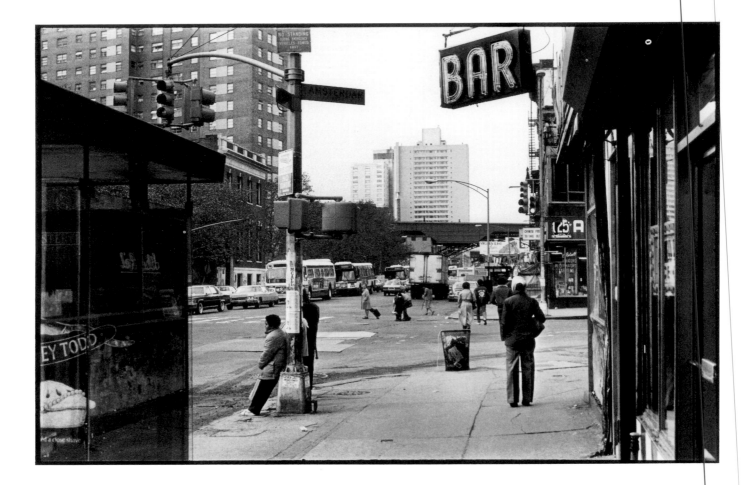

Waiting for a bus. Harlem, USA. 1981

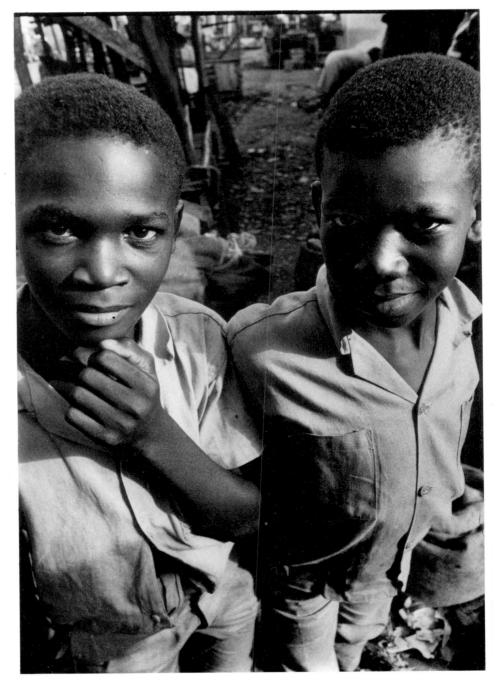

May Pen Market. May Pen, Jamaica. 1969

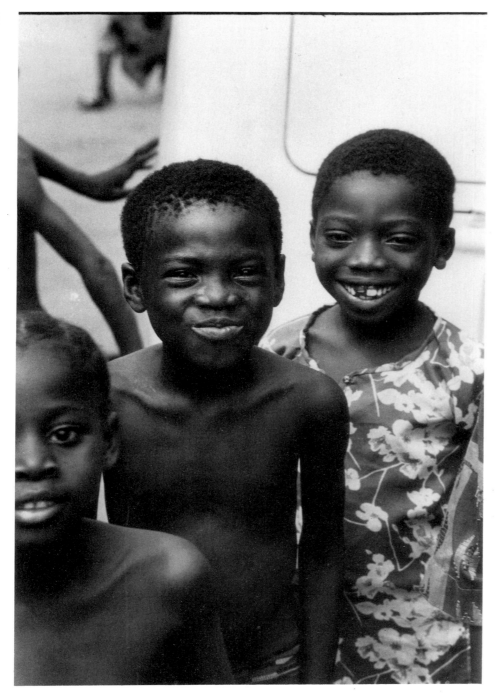

Having fun. Lagos, Nigeria. 1977

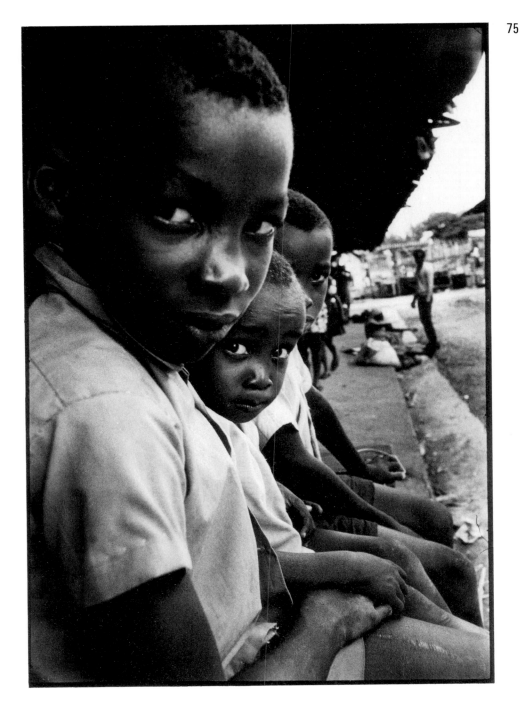

Waiting in the Market Place. May Pen, Jamaica. 1969

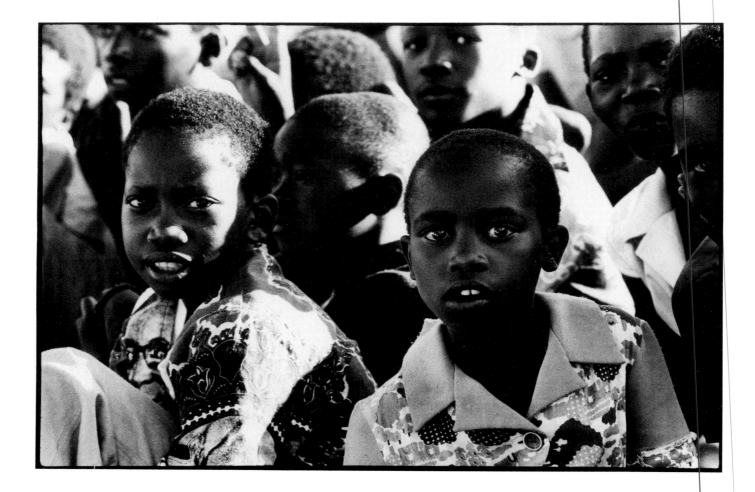

Watching music show. Zimbabwe. 1981

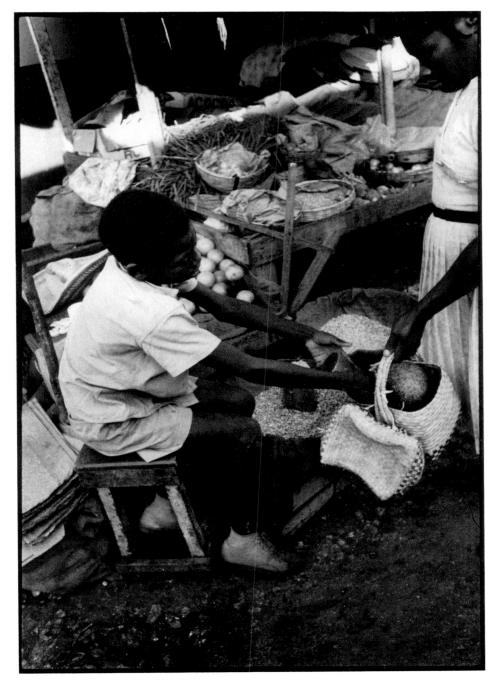

Selling in the market. Kingston, Jamaica. 1981

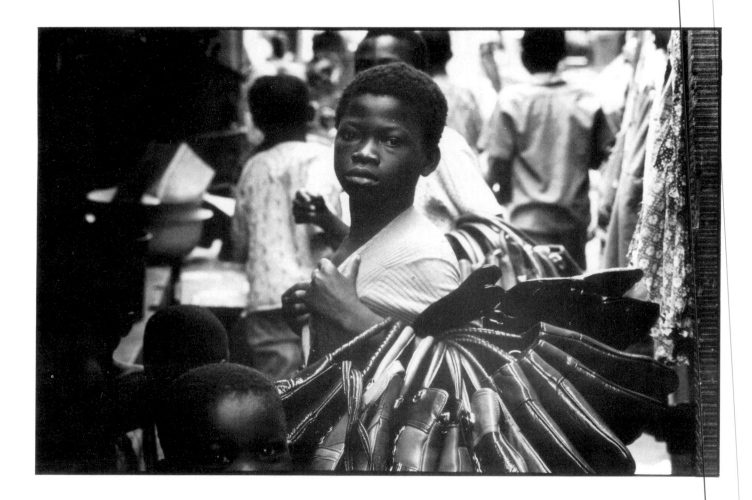

Selling in the street market. Lagos, Nigeria. 1977

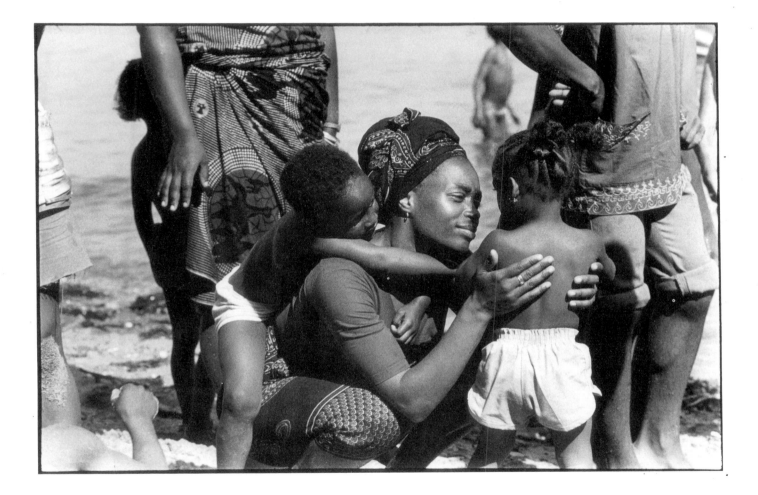

Day at the seaside. Hastings, UK. 1983

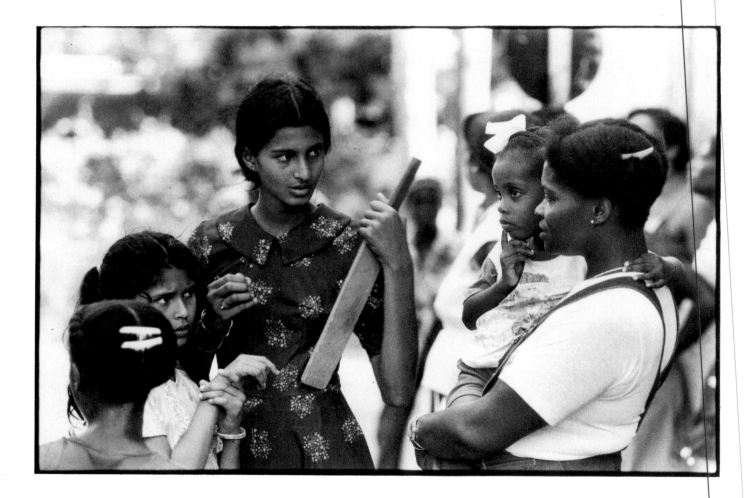

Talking. Fruitful Vale, Jamaica. 1980

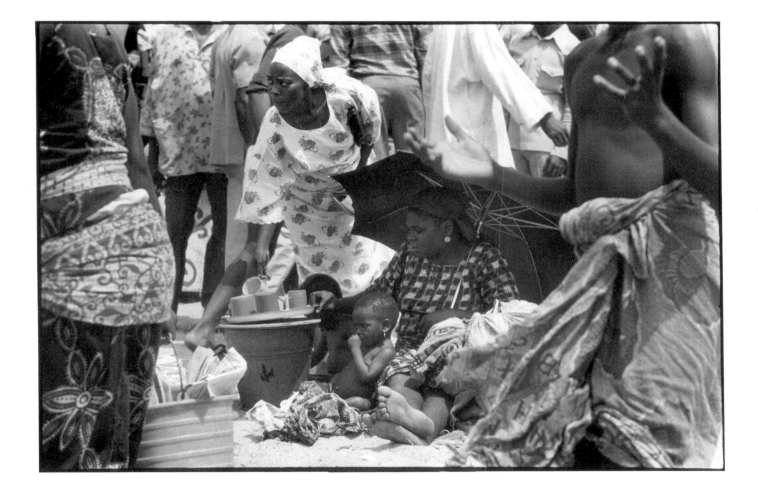

Street market. Lagos, Nigeria. 1977

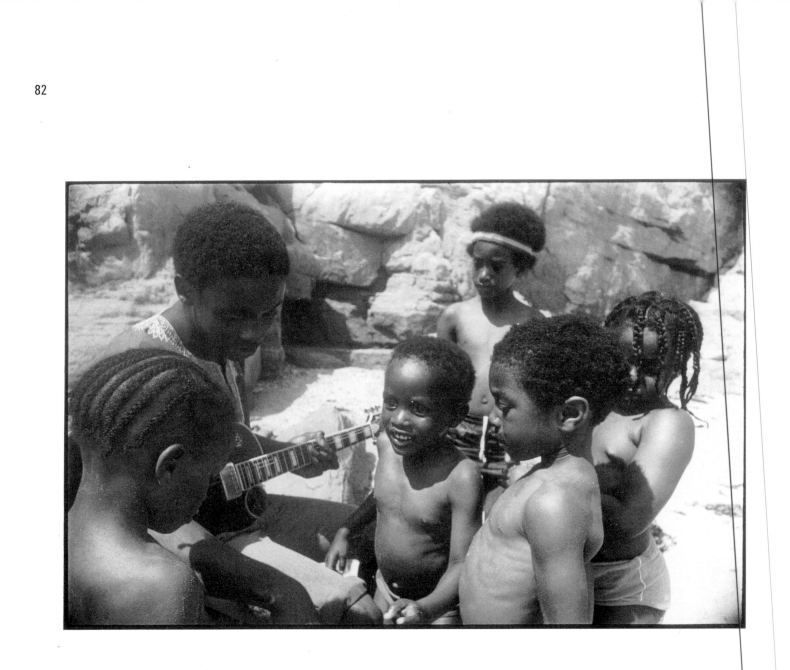

Day at the seaside. Hastings, UK. 1983

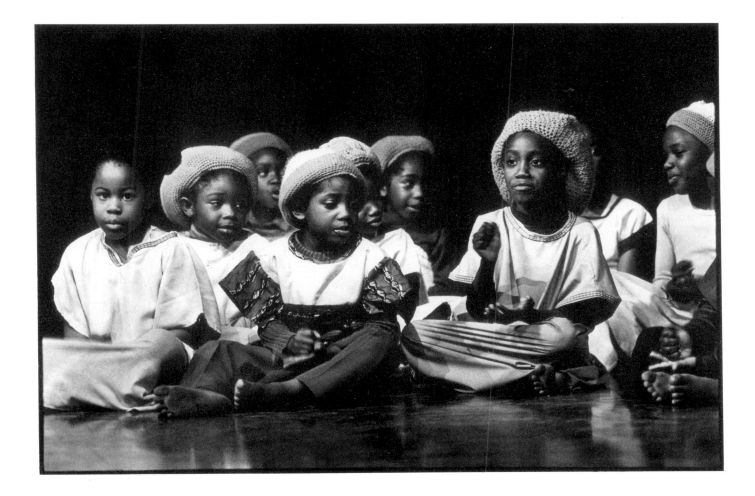

Performing on stage. London, UK. 1980

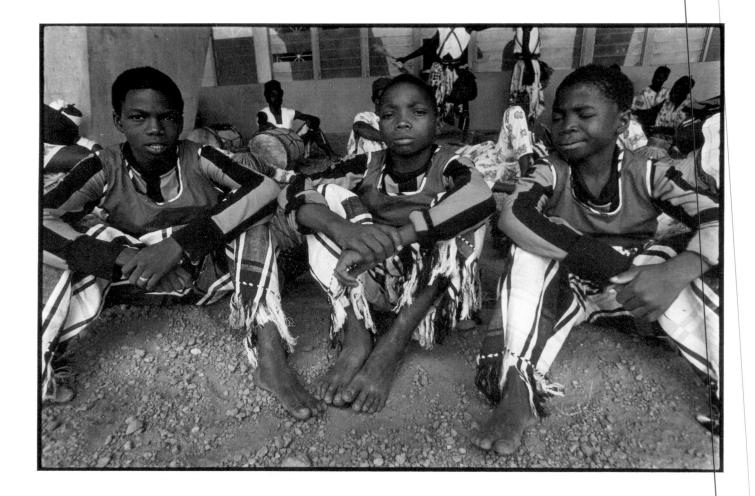

Taking a rest after show 'Festac'. Lagos, Nigeria. 1977

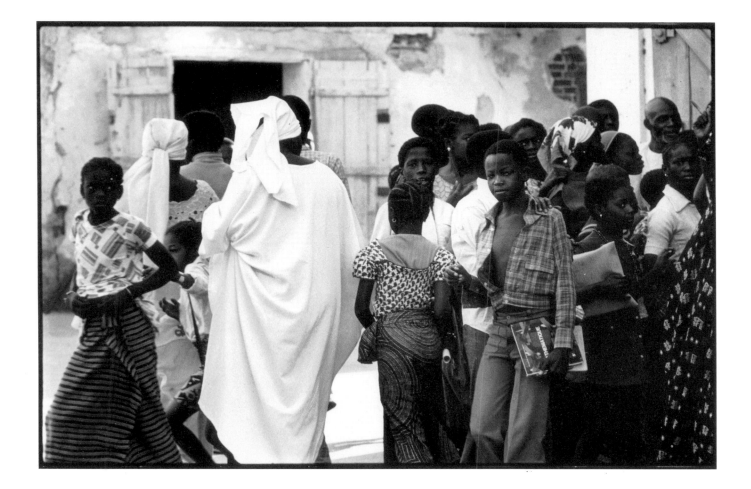

Street scene. St. Louis, Senegal. 1976

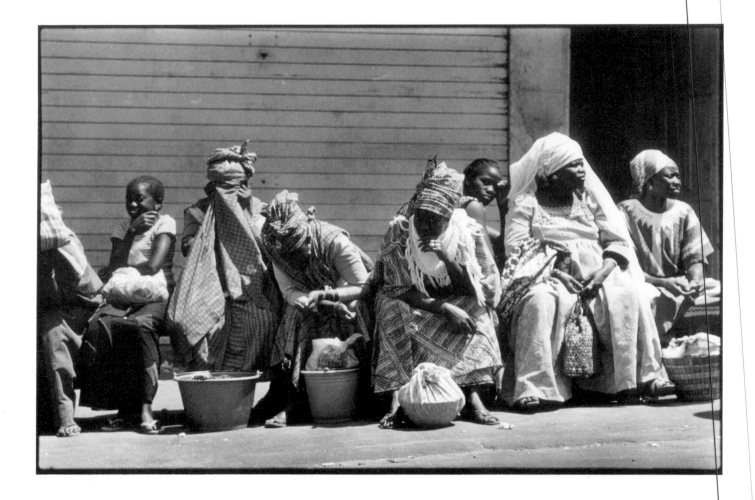

Waiting for transport. St. Louis, Senegal. 1976

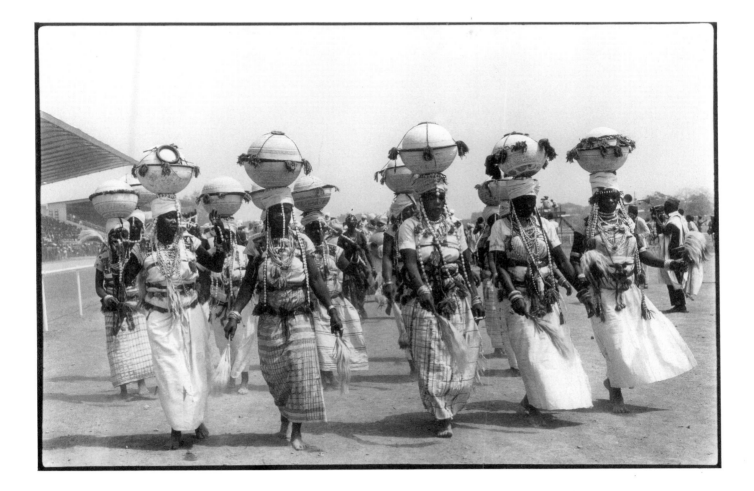

Traditional dance 'The Derba'. Kaduna, Nigeria. 1977

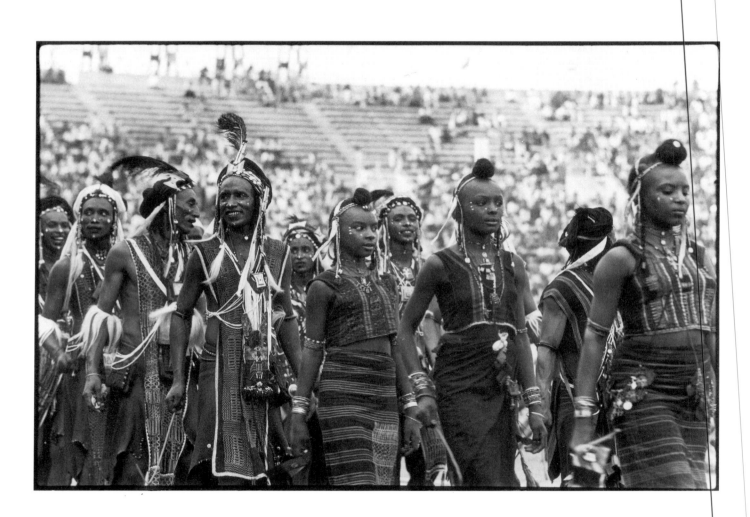

Traditional dance 'The Derba'. Kaduna, Nigeria. 1977

APPENDIX (i)

Fortunately, there are reasons for hope due mainly to the fact that, low-cost means exist today that can go a long way towards preventing such large-scale deaths. The techniques have been developed by UNICEF into what is known as the Child Survival and Development Revolution (CSDR). They are based upon a combination of technological breakthroughs and intense social communication efforts. Commonly referred to as GOBI, such techniques stand for Growth Monitoring, Oral Rehydration Therapy, Breast feeding and Immunisation. Summarised below is how such techniques can make CSDR possible.

Growth monitoring, a detailed chart at the disposal of all mothers

Malnutrition is not something that can always be detected by the naked eye. In fact, only 1% of the world's children are visibly malnourished. The rest suffer from invisible malnutrition which prevents mothers from doing something about it before it is too late. Making it therefore possible for the mother to see the malnutrition in her children will be crucial towards protecting them. Today, this is done through growth-monitoring charts which indicate progress or lack of it by the child, thereby enabling the mother to prevent much of the malnutrition in developing countries. In Jamaica, for instance, systematic use of growth-monitoring programmes among 6,000 children reduce the country's malnutrition rate to 40% and that of infant mortality of 60%. The technique is simple and it can be performed by any mother; it consists mainly in weighing the child monthly and entering the information on the chart. Special charts exist even for illiterate mothers.

Oral rehydration therapy (ORT), the answer to the biggest child killer

The biggest killer of children is dehydration induced by diarrhoea infections, taking 5 million lives in the developing world, including 1 million in Africa. It comes about mainly during the weaning period, when the child starts having larger amounts of food to supplement the breast milk.

The natural instinct of mothers, when a child has diarrhoea, is to stop the feeding. Or sometimes it is just that the child has lost appetite and it continues to lose fluid. And if a child stops eating the consequence is best described by James Grant: 'In a matter of hours now, the child's skin begins to lose its resilience and the thirst becomes unbearable, though the child may not have the energy to express it.

'Without urgent treatment, 10% of body weight is soon lost. Now shock sets in, and so does stupor. Blood pressure begins to drop. The pulse quickens. Within minutes the kidneys begin to malfunction. Acid build up in the body. Peripheral blood cells begin to collapse.'

For many years, the only way to deal with dehydration was through intravenous feeding of solutions. Sometimes patients were made to drink solutions of salt and water. The problem with the former was that it had to be administered by qualified medical personnel thereby making it too expensive for most mothers. As to the latter, the absorption of the solution was inhibited by the diarrhoea infection itself. The big recent discovery was that, by adding some sugar to the salt and water solution, the absorption capacity increased dramatically. Oral rehydration therapy (ORT) is therefore the discovery of that solution. The magic solution continues to perform wonders in countries as far apart as Trinidad and Tobago and Egypt, Guatemala and India, Haiti and Bangladesh.

In Trinidad and Tobago, infant mortality from diarrhoea dropped by 60% in the General Hospital of Port of Spain, following replacement of intravenous feeding ORT. The same process was observed in Haiti when child deaths at the State University Hospital dropped dramatically from 40% to 1%, after the introduction of ORT in 1980.

Breastfeeding, the best way forward

Some people may wonder why we need to talk about breastfeeding in the drive to protect children since this may be a technique already used by mothers all over the Third World. The sad fact is that the dairy industry, assisted by powerful advertising, threatened to swing the clocks back to the use of milk powder, as a substitute for breast milk. From a medical point of view, there is no question about the positive impact of breast milk on the growth of children.

This medical evidence is supported further by the sight of babies shining with health even in the poorest villages or slums, during the first six months of their lives when they are breast fed. At a time when middle-class women in industrialised countries are returning more and more to breastfeeding unfortunately we can only observe alarming indications of its decline in places like Africa.

Immunisation, the cutting edge

Last but not least in the GOBI combination is immunisation. Its promotion was enhanced by the adoption by the World Health organisation of a resolution aimed at Universal Child Immunisation against six diseases by 1990 — measles, tetanus, whooping cough, diphtheria, poliomyelitis and tuberculosis. The combined cost of the vaccines for such diseases does not exceed five American dollars (less than three pounds sterling). Many countries have enthusiastically embraced immunisation programmes, including 21 African countries. But serious organisational and logistic problems continue to hamper progress in the field of immunisation. We will come back to this issue when we are dealing with the challenge of social communication below.

To the GOBI techniques UNICEF adds the optimal use of three additional elements directed towards mothers: Food supplements, Family spacing and Female education which turns the acronym into GOBI-FFF.

Social Mobilisation, the vital link

Needless to stress that no matter how efficient GOBI-FFF is, it is only a series of technological know-how. It will not make any difference without the full support of families and communities. It is at this juncture that newly found communications advances come in as the other big set of breakthroughs in the drive for the Child Survival and Development Revolution. Mobilising all organised forces of a given country is essential to the success of CSDR. The issue boils down to education and information sharing among parents, communities and opinion leaders about how to nurture, protect and save our children.

For instance, a challenge facing immunisation in Africa is that at least three shots, spaced out in time, are necessary for a child to be fully covered. But for a mother to come back for the remaining shots when her child has developed fever after the first shot and is thinking 'Why should I take back my child for the second or third shot, if they just make him sick', the educational process will consist in convincing the mother to come back for the remaining shots and for her to realise that it's all right for her child to develop fever; that it is no sign of sickness, and that on the contrary, it is a protection against future sickness.

The challenge becomes political rather than technological or financial. How to get the message across to the remotest village? UNICEF has pioneered a few techniques in this area which have begun to make a difference. They consist in mobilising modern channels of communication, such as the radio, television and newspapers, with traditional means such as the African bards, known as 'griots' in West Africa, to those channels one would add an alliance with school teachers, religious leaders, women's organisations and youth movements as well as Heads of state, ministers and parliamentarians. A case in point is how Senegal managed to increase its immunisation cover from 20% to 75%, in six months in 1987, thereby saving the lives of 30,000 children a year. The key was the involvement of the top leadership from the outset. President Diouf talked to the media, to leaders of opposition parties and to provincial governors. He then recruited imams and priests as well as businessmen. Fridays are the big days for prayers among muslims and every Friday, imams would tell muslims that it is against the will of God not to immunise one's child. Youssou N'Dour, the country's most famous performer was also involved. He donated radio and television spots; and a photograph where he was holding a baby being immunised was turned into a poster and distributed throughout the country.

In fact the idea of involving people like Youssou N'Dour comes from an idea conceived by the UNICEF Executive Director to seek the support of African artists and intellectuals. The concept was launched during a symposium last March in Dakar, Senegal. For three days, the Senegalese capital became the centre of intensive consultation, debate and controversy among the 50 writers, filmmakers, performers and painters. They had gathered to find ways to harness their talents to one specific element of the continent's social agenda: rapidly reducing the large-scale and needless death among its children. How do these accomplished communicators who inspire such passion and large following get across to all African mothers the message that, thanks to newly-found low-cost methods, their children have better chances of survival today than ever before? That was the challenge posed by UNICEF, the sponsor of the symposium.

Harry Belafonte, the famous American performer, put his full weight behind the symposium by making the trip to Dakar and taking full part in the debates. It was his first project as a Goodwill Ambassador for UNICEF.

APPENDIX (ii)

Help to spread the word — millions of people in Africa, the Caribbean and elsewhere need urgently to know about the Child Survival techniques. Write to newspapers, radios and television stations.

Help others to understand, for instance through seminars, complexities behind child survival measures, the fact that all the above mentioned techniques have to be applied together.

Contribute financially to organisations of your choice working for children. What matters is not the amount you contribute but the fact that you contribute. It sends a powerful message to governments and other leaders as to where you would like some of taxpayers' money to go.

Set up a network with other friends to exchange information on the quality of life among women in particular.

'For us, it's too late, but we don't want our children to have the same life that we have had' these words from a mother living in a remote village of Burkina Faso eloquently describe the concern of every parent which is to provide good life, hope and well being for each and everyone of their children. But I hope that I have just demonstrated that the responsibility for turning that key that will unlock the potential for Child Survival and Development in Africa and the Diaspora, should not rest on mothers or parents alone. It is the responsibility of each and everyone of us.

Djibril Diallo
Senior Information Officer, UNICEF New York USA.

BLACK CHRONOLOGY

B.C.

4500 Appearance of KMT (ancient Egyptian civilisations along the river Nile).

2980 Imhotep, first recorded doctor, active in KMT.

1361 Pharaoh Tutankhamen begins his ten year reign.

900 Civilisation of Nok appears in Central Nigeria.

600 Evidence of established trading line between East Africa and India.

300 Euclid, mathematician and author of 'The Elements', living in Alexandria in KMT.

A.D.

127 Ptolemy, geographer, astronomer and mathematician, author of 'Geography' born.

189 Pope Victor I elected head of the Catholic church. During his papacy, Latin was established as the Church's official language.

200 Destruction of Nok civilization in Nigeria. Evidence of Black presence in Britain.

311 Pope Melchiades elected head of Catholic church.

1150 Idrisi, brilliant Nubian Geographer publishes his major work 'The Third Climate'.

1200 Emergence of Ile-Ife and Benin schools of representational sculpture in Nigeria.

1230 Rise of Mali, a vast west African empire. Its university city of Timbuctu was famous throughout the medieval world.

1311 Possible voyage of Abubakari II Emperor of Mali, to the Americas.

1331 Establishment of the Ethiopian empire with the unification of scattered Christian kingdoms.

1400 Rise of Christian cult of St. Maurice (based around the legendary Nubian crusader) in medieval Europe.

1492 Pedro Alonzo Nino recorded as Black participant in the Columbus expedition to the Americas.

1493 Songhai established with foundation of the Askia dynasty. This extensive West African empire was a rival and successor to Mali.

1507 Foundation of Kingdom of Dahomey ('Dauma'). Establishment of the University of Sankore in Songhai. It boasted faculties of law, literature, geography and medicine.

1560 Independent Black government declared by Maroon rebels in Panama. Maroons were independent Black communities, often organised on African lines.

1637 Gen. Henry Diaz active. Diaz commanded a Portuguese army in a war against Holland.

1684 Lorenzo de Silva Mendoza, Black Procurator General of a religious group in Rome, attempts to secure a Vatican ban on the slave trade. His proposals though adopted are never implemented.

1690 Portuguese troops are driven from Mashonaland (Zimbabwe) by Changamire, King of Rozwi.

1697 Osei Tutu, political theorist and traditional priest, unifies Akan people and creates the Asante state in the area of modern Ghana.

1700 John Chavis becomes the first black student at Princeton University, U.S.A.

1762 Fraunces Tavern opens in New York City. This tavern was frequented by George Washington and its proprietor, Samuel Fraunces, was instrumental in foiling an attempt on Washington's life.

1786 Geoffrey L'Islet becomes the first Black member of French Academy of Science.

1802 Alexandre Dumas, novelist and playwright, author of the 'The Three Musketeers' born in France.

1821 Harriet Tubman, nurse, military scout and scout and federal secret agent, born a slave in Maryland, Tubman was a conductor on the celebrated underground railroad.

1822 'Freedom Journal' founded the first black newspaper in the U.S.A.

1838 Andre Reboucas, engineer, and abolitionist born. Among other projects, Reboucas designed the docks at Rio de Janeiro.

1844 M.B. Allen and R. Morris become first black lawyers in the U.S.A.

1858 Dr. Daniel Hale, first successful open heart surgeon, born, in U.S.A.

1861 George William Gordon launches his constitutional reform movement in Kingston, Jamaica.

1863 Queenmother Yaa Asantewa born in Asante, Ghana.

1864 Rebecca Lee becomes the first black woman doctor in the U.S.A.

1866 Mathew Henson, Polar explorer, born in the United States.

1868 W.E.B. Dubois, writer, Pan-Africanist and civil rights activist, born the U.S.A.

1868 Scott Joplin, musician, and composer, born in the U.S.A.

1870 H.R. Revels becomes the first Black Senator in the U.S.A.

1878 B.H. Taylor patents a rotary engine.

1890 William Purvis patents a fountain pen.

1893 Semori, legendary West African resistance leader, dupes British and French troops into fighting each other in Senegal.

1900 First Pan-African Conference held in London.

1901 C.L.R. James, journalist, historian and Civil rights worker, born in Trinidad.

1902 Langston Hughes, poet, writer, born in the U.S.A.

1904 Dr. Sir Charles Drew develops method for the extraction and manipulation of blood plasma.

1904 B. Naamdi Azikiwe, journalist and politician born in Nigeria.

1909 Dr. Kwame Nkrumah, writer, politician and Pan-Africanist, born in Ghana.

1910 National Association for the Advancement of Coloured People (N.A.A.C.P.) founded in the U.S.A.

1912 African National Congress (A.N.C) founded in South Africa.

1914 Almost one million Black people from Africa, the Caribbean and the Americas fight for both sides during World War I.

1917 Gwendolyn Brooks, first Black writer to win the Pulitzer Prize born in the U.S.A.

1919 Extensive riots and political disturbances across South Africa as Black People protest against the hated 'Pass' system.

1921 Julius Nyerere, teacher, politician born in Tanzania.

1925 Dr. Frantz Fanon, writer, civil right activist, born in Martinique.

1925 George Jackson, author and civil rights activist, born, in the U.S.A.

1925 Malcolm X, writer, revolutionary born in the U.S.A.

1929 Dr. Martin Luther King, theologian, writer and civil rights activist born in the U.S.A.

1930 Chinua Achebe, prizewining novelist, born in Nigeria.

1936 J.C. Owens wins 4 Olympic gold medals in Berlin.

1942 Jimi Hendrix, musician, born in the U.S.A.

1945 Six Black scientists work on secret 'Manhattan Project' to produce atom bomb.

1947 Présence Africaine founded by Black people in Paris.

1952 Land and Freedom Army uprising in Kenya. This guerrilla war of independence continued for several years despite the efforts of the British who branded African resisters, 'Mau Mau'.

1959 101st Airbourne Div. escort Black children to school, Little Rock, Arkansas, U.S.A.

1961 Patrice Lumumba, Prime Minister of the Congo (modern Zaire) and architect of Congolese independence, assassinated.

1964 Nelson Mandela leader of the ANC imprisoned in South Africa.

1977 Steven Biko, civil rights activist and leader of the black Consciousness Movement author of 'I write What I Like' assassinated by the South African Police.

BIBLIOGRAPHY

An increasing number of books are appearing on African and Black history topics. Lots of exciting new study is being conducted both within and outside Africa. Unfortunately, it's sometimes the case that 'new' books on Africa simply recycle discredited and racist ideas. For this reason it's often worthwhile looking at several interpretations of any African historical question. This list contains a small selection of the many useful books currently available, it includes more recent titles as well as some Black History 'Classics'.

Classics
How Europe Underdeveloped Africa.
Dr.Walter Rodney
Tanzania (1972)
The African Origin of Civilization.
Cheikh Anta Diop
Lawrence Hill (1974)
The Real Facts About Ethiopia
J. A. Rogers
Helga M. Rogers (1935)
African History
E. Sweeting & L. Edmond
LSPU reprint (1988)

General History
Sex & Race, vols. I, II & III.
J. A. Rogers
Helga M. Rogers (1944)
World's Great Men of Color,
* vols. I & II.*
J. A. Rogers
Collier Macmillan (1972)
Black Chronology
Ellen Diggs
Boston (1983)
Africa in Modern History
Basil Davidson
Allen Lane (1976)

Black Power and the Garvey Movement
T. G. Vincent
Ramparts Press (1971)
African Profiles
Ronald Segal
Penguin (1962)
Asante in the Nineteenth Century.
Ivor Wilkes
Cambridge University Press (1975)
Blacks in Science.
Ivan van Sertima (ed)
Transaction (1983)
Travels in Africa and Asia
Ibn Battuta
R.K.P. (1983)
Great African Thinkers; Cheikh Anta
* Diop*
ed. Ivan van Sertima
Transaction (1986)
British Historians and the West Indies
Eric Williams
Andre Deutsch (1972)
Capitalism and Slavery
Eric Williams
Andre Deutsch (1981)
Under the Imperial Carpet
R. Lotz & I. Pegg (eds)
Rabbit Press (1986)

Slaves who abolished Slavery,
* vols. I & II*
Richard Hart
Univ. of West Indies (1985)

Africa and the Ancient World
Black Athena
Martin Bernal
Free Association Press (1987)
Before Color Prejudice
Frank M. Snowdon
Harvard (1983)
Nile Valley Civilizations
Ivan van Sertima (ed)
Transaction (1985)
The Peopling of Ancient Egypt
Unesco Symposium Papers
UNESCO (1978)

Women
Women Leaders In African History
David Sweetman
Longman
The Wonderful Adventures of
* Mrs Seacole*
Z. Alexander & A. Dewjee
Falling Wall (1984)

Jazzwomen
S. Placksin
Pluto (1982)
Women, Race & Class
Angela Y. Davis
Women's Press (1982)

South Africa

The War Against Children, South Africa Youngest Victims
Lawyers Committee for Human Rights
New York (1986)
Apartheid, Power and Historical Falsification.
Marianne Cornevin
UNESCO Paris (1980)

Britain

Staying Power
Peter Fryer
Pluto Press (1984)
Black Britannia
Edward Scobie
Johnson (1972)
A history of the Black Presence in London
GLC Publications (1986)

Behind the Frontlines: Journey into Afro-Britain
Ferdinand Dennis
Gollancz (1988)
Making of the Black working class in Britain
Ron Ramdin
Gower Press (1987)

The African Diaspora

Africans Abroad
G.W. Irvin
New York (1977)
Black Folk Here and There
St. Claire Drake
UCLA (1987)
They came Before Columbus
Ivan van Sertima
Random House (1976)
The African Presence in Early Europe
Ivan van Sertima
Transaction (1985)

Illustrated Books

A-Z of Jamaican Heritage
O. Senior
Heinemann (1983)

Africa's Gift to America
J.A. Rogers
Helga M. Rogers (1961)
Black History for Beginners
Dennis and Willmarth
Readers & Writers (1984)
The Black West
William Lorenz Katz
Open Hand (1987)

Politics

Ethnocentrism and History
Roy Preiswerk & Dominique Parrot
Nok (1978)
Discourse on Colonialism
Aimé Césaire
Présence Africaine (1955)
African Must Unite
Kwame Nkrumah
Panaf (1963)
Black Skin, White Masks
Franz Fanon
Grove Press (1967)